SCOTT McFARLAND

TEXTS BY GRANT ARNOLD, MARTIN BARNES, VINCENT HONORÉ, EVA RESPINI, SHEP STEINER

VANCOUVER ART GALLERY

VANCOUVER

DOUGLAS & McINTYRE

D&M PUBLISHERS INC.

VANCOUVER/TORONTO/BERKELEY

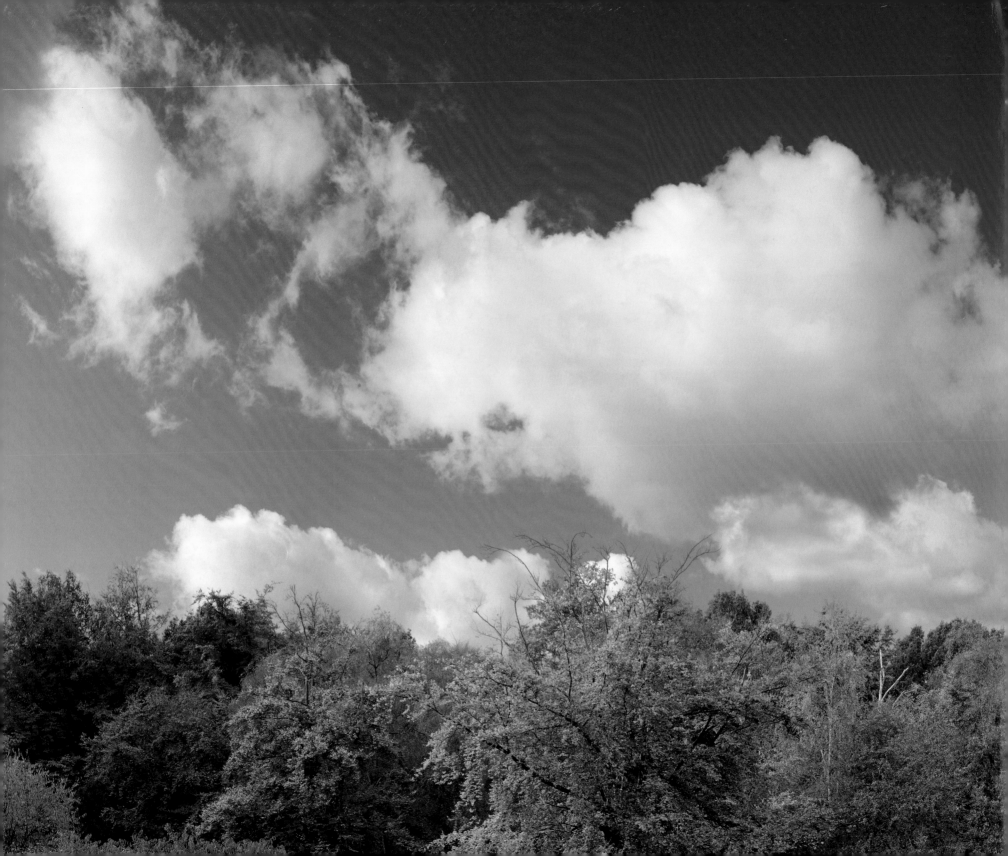

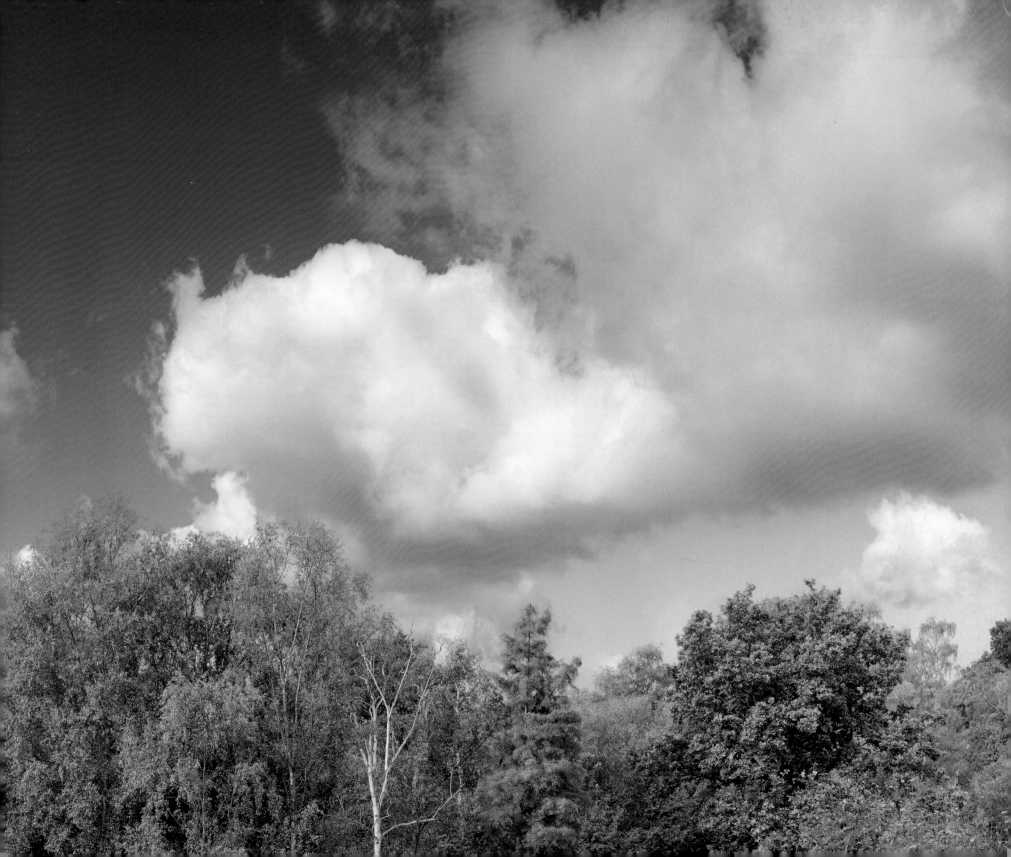

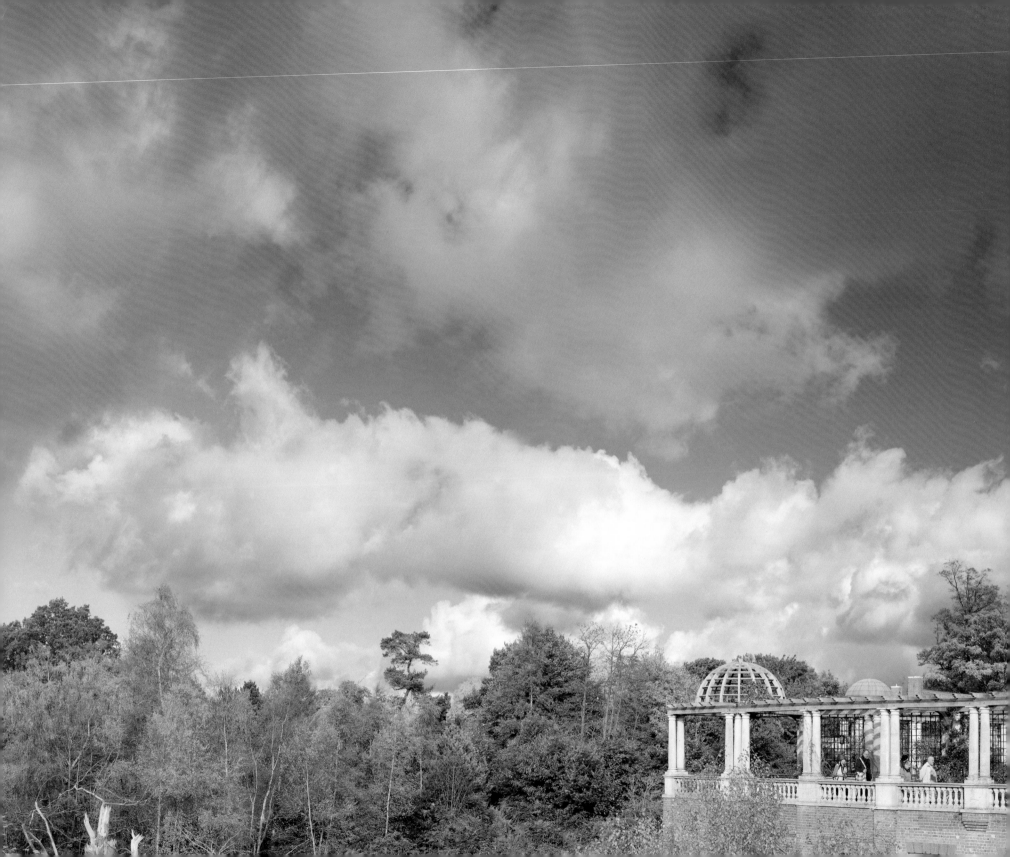

CONTENTS

Hill Garden Pergola, Looking towards West Heath (edition 1/5), 2009

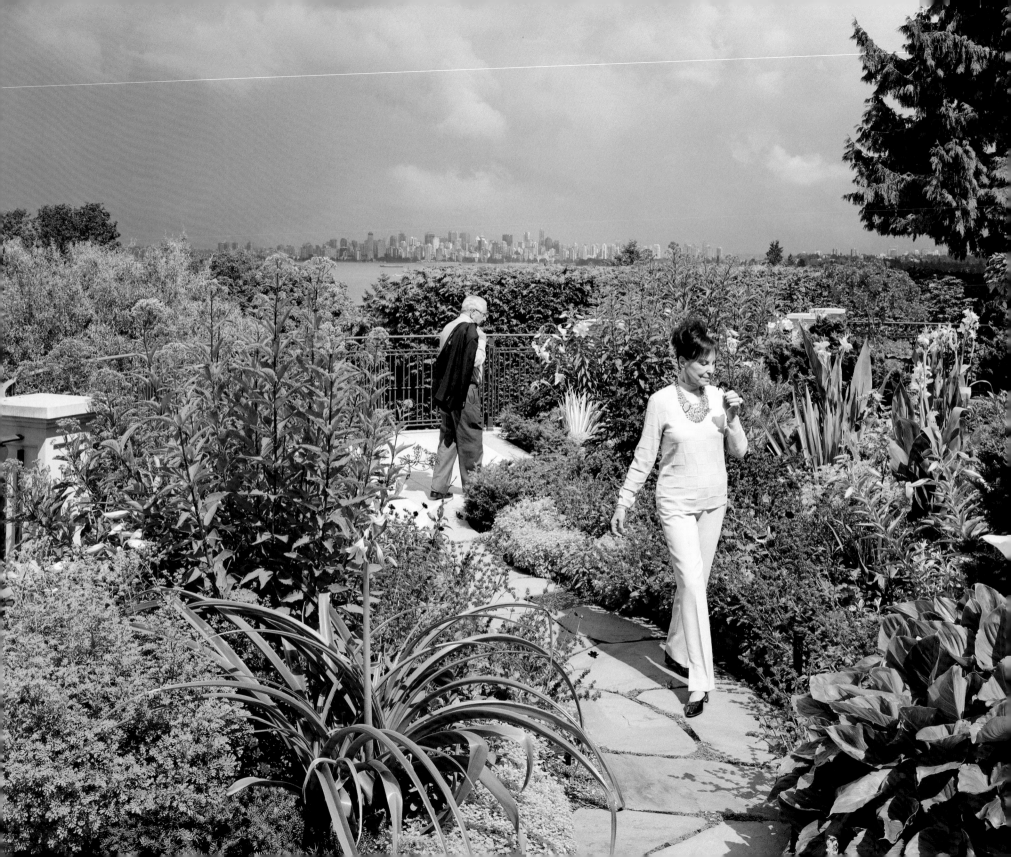

DIRECTOR'S FOREWORD Kathleen S. Bartels

The Vancouver Art Gallery is proud to present this exhibition and book that focus on recent photographs by Scott McFarland. Over the past twelve years, McFarland has produced a significant body of work that has been widely exhibited in North America and Europe and has positioned him as a prominent figure in the current generation of artists working with photography. During that time, McFarland's photographic practice has examined gardens, darkrooms, zoos, cabins and boathouses as platforms for everyday activity and art historical inquiry. His subtle digital manipulations of the photograph, in which many separate exposures are presented together as a single image, reflect his personal experience of a site over multiple visits and destabilize the viewer's expectation of the photograph as proof of a single moment in time. The resultant pictures are remarkable in their engagement of public and private, macro and micro with seamless clarity.

This important exhibition would not have been possible without the support of many individuals and organizations. We are deeply grateful to the Presenting Sponsor for the exhibition, Sotheby's International Realty Canada, for their financial support of this project. Our sincerest thanks are owed to David and Carol Appel for their significant support that has enabled the Gallery to produce this comprehensive catalogue chronicling Scott McFarland's work. In addition, the Gallery's gratitude is extended to the Albert and Temmy Latner Family Foundation for their contribution. I would like to acknowledge Monte Clark of the Monte Clark Gallery, Vancouver, Daniel Faria of Clark & Faria, Toronto, and Shaun Caley Regen and Jennifer Loh of Regen Projects, Los Angeles, for their assistance. The Gallery is also grateful for the cooperation of the individual lenders who have generously loaned artworks from their collections. Thanks to Kelsey Blackwell for her inspired design of this book and to our co-publisher, Douglas & McIntyre, for their commitment to its production. Our appreciation also extends to Martin Barnes, Vincent Honoré, Eva Respini and Shep Steiner for the informative essays they have contributed, and to Grant Arnold, Audain Curator of British Columbia Art, who has shed light on McFarland's practice and organized the exhibition. I am deeply indebted to the Gallery's Board of Trustees for their committed support, and to the staff at the Vancouver Art Gallery who have contributed to the realization of this project. Finally, I would like to extend our deepest thanks and appreciation to Scott McFarland for his beautiful and thought-provoking work.

On the Terrace Garden, Joe and Rosalee Segal with *Cosmos atrosanguineus*, 2004

PICTURE WORK: SCOTT McFARLAND'S RECENT PHOTOGRAPHS

Grant Arnold

*The charm of nature lies in her mystery and poetry, but no doubt
she is never mysterious to a donkey.*
Peter Henry Emerson, 1889[1]

*Photography aspires to art each time, in practice, it calls into question its
essence and its historical roles, each time it uncovers the contingent character
of these things.*
Hubert Damisch, 1963[2]

*It is easy to identify oneself deep down inside with the psychoanalytical,
disembodied Oedipus, but not with the Greek king Oedipus. In contemporary
photography, the entire history of painting is repeated photographically in a
comparable manner—no longer as a history of gifted bodies but as a history
of intellectual attitudes, of the disembodied gaze.*
Boris Groys, 1998[3]

This book and the exhibition it accompanies focus on recent photographs by
Scott McFarland, a relatively young Canadian artist who has relocated to
Toronto after being based in Vancouver since the early 1990s. Over the past
decade, McFarland has developed a significant body of rigorously composed
photographs that explore a range of environments—manicured private land-
scapes, botanical gardens, public parks, zoos and the pastoral fringes of urban
space—as sites through which the intersection between civilization, nature and
the particular character of photographic representation can be investigated.
Drawing upon the history of landscape painting and photography, McFarland's
meticulously considered pictures engage with the persistent human desire to be
in proximity to nature and the related need to classify, control and reproduce
the natural world, which has shaped landscape as a genre within the visual
culture of the Western world over the past three hundred years.

Embers, Late Evening, 2002

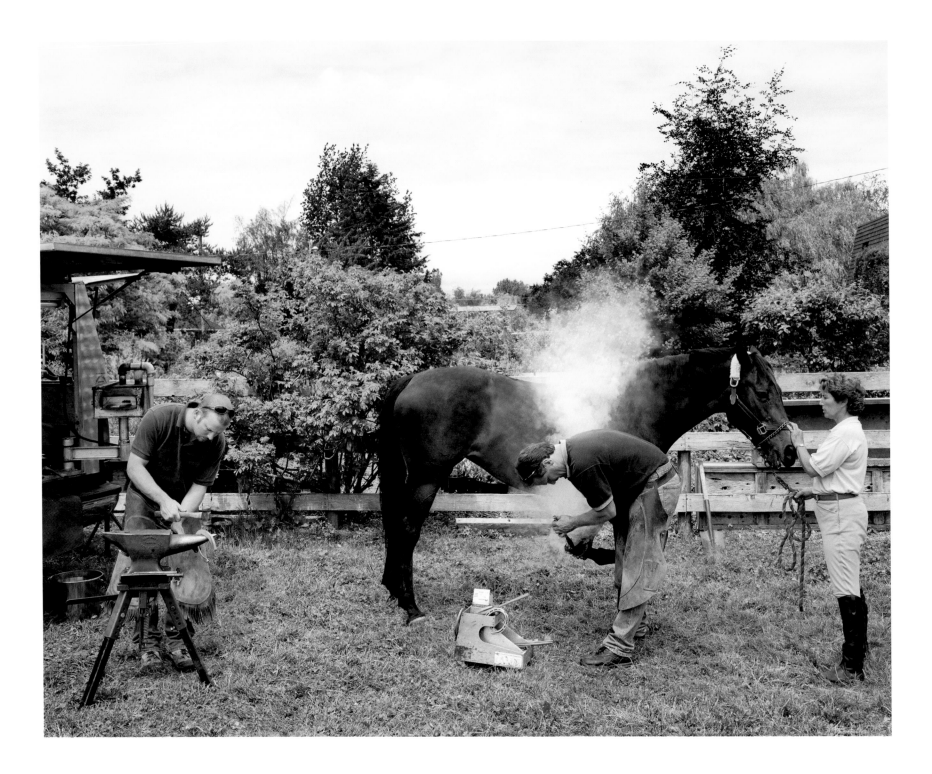

Although the places McFarland photographs are widely dispersed geographically, his images are shaped by a familiarity and knowledge that emerge from extended observation and repeated visits. He rarely makes single images; the relationship with a site typically results in a suite of distinct but related pictures. Each body of work usually includes a set of studies of a given locale and one or more large-scale pictures, often in a panoramic format. While photography's ability to describe is unquestionably of interest to McFarland, he makes no attempt to provide a comprehensive overview or document of the places on which he turns his camera. As William Wood has pointed out, McFarland breaks with a documentary tradition in which a series of images visually circumscribes a place, in favour of a body of work developed to address "the idea of a locale, of the manifold picturing of a site where events occur or have occurred, where something meaningful has accumulated that is worth thinking over."[4] Although the genteel character of McFarland's subject matter is a departure from the urban dead zones and de-featured landscapes that have been the focus for much of the photography produced by Vancouver-based artists over the past twenty years, his images can be clearly situated in a tradition of photographic work that has been associated with Vancouver artists such as Ian Wallace, Jeff Wall and Roy Arden, in which interest in the descriptive power of the photographic image is deployed and, at the same time, tempered by a skepticism towards the claim to truth long associated with the medium.

The conceptual parameters for McFarland's work were generated with a body of large-scale colour photographs that examined the role nature plays as a trope in the private gardens and properties of Vancouver's monied elite. His interest in photographing gardens developed, in part, from his interest in the origins of photography and the role of botany in the work of William Henry Fox Talbot. Talbot, inventor of the negative/positive photographic process, used plants as subject matter in his early experiments on photographic materials, producing "photogenic drawings" by placing botanical specimens directly onto paper made light-sensitive with an emulsion of silver salts. Along with early photographers such as Hippolyte Bayard, Henri Le Secq, Roger Fenton and John Llewelyn, Talbot turned to the garden as readily accessible subject matter that provided the kind of image that underscored a perception of photography as a process through which the natural world traced its own image without the subjective distortion associated with painting and other, more traditional forms of reproduction. For McFarland, the act of producing and maintaining a garden—of constructing a facsimile of nature intended to provide visual pleasure, a process that necessarily involves decisions on which elements to include or remove, which components to make visible or elide—parallels that of producing a photograph. The garden, then, served McFarland as a subject that could introduce questions of landownership, social status, the visibility of labour and desire for the idyllic, while simultaneously alluding to the history and premises of photography as a reproductive technology.

Produced using standard analog materials, McFarland's earliest garden photographs include images of privately owned formal gardens on vacated properties in the affluent Point Grey area of Vancouver, their untended state evoking the fading hegemony of the city's traditional WASP social elite, as well as richly detailed studies of garden plants and images of hired gardeners re-enacting their maintenance tasks, which underline the intersection of the staging of nature with conceptions of social status.

Reshoeing, Farrier James Findel with Assistant on Southlands, 2003

The question of space and who gets to occupy it was extended further in a body of photographs depicting a rustic cabin on the Sunshine Coast regularly used by a friend's family as a retreat from the demands of city life. This project included a large colour photograph of the exterior of the cabin and the surrounding forest at night, paired with a video of the same scene sporadically illuminated as a motion detector repeatedly switches on a security light in response to the presence of the photographer. Confronted with an apparently unending cycle of darkness and illumination, viewers were left to ponder which of the two offered more comfort and to consider whether their presence would register as owner, guest or intruder.

Selections from McFarland's *Cabin* project were included in a 1999 exhibition titled *After Photography,* curated by Roy Arden for the Monte Clark Gallery in Vancouver. In his text for the exhibition brochure, Arden located the work of McFarland and several of his contemporaries within a broader realist tendency marked by an understanding of "appearance as the singularly important aspect of visual art."[5] The exhibition was intended as a counterpoint to *Before Photography,* an exhibition organized by the Museum of Modern Art in 1981 that claimed paintings produced before 1839 by artists such as Jean-Baptiste Corot, John Constable, Caspar David Friedrich, John Sell Cotman and Christen Købke prefigured an aesthetic that would become associated with photography later in the nineteenth century. Arden's thesis was based on his observation that, at a moment when analog photography was becoming obsolete with the development of digital technologies, the work of the artists represented in *After Photography* retained an affinity with the sort of natural science that "Constable proposed as a model for art,"[6] while avoiding digital manipulation and turning to the everyday for subject matter. For Arden, these pictures could, therefore, be aligned with a paradigm of art-making that originated in northern Europe during the seventeenth century, which the critic and historian Martin Jay

Cabin with Motion Light, 2001

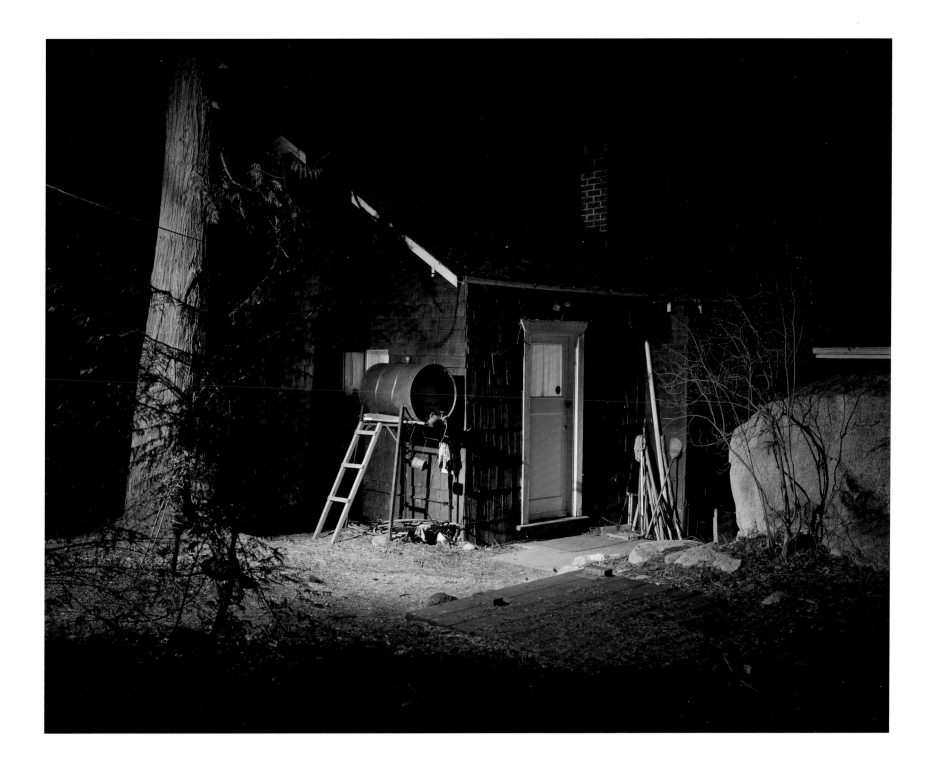

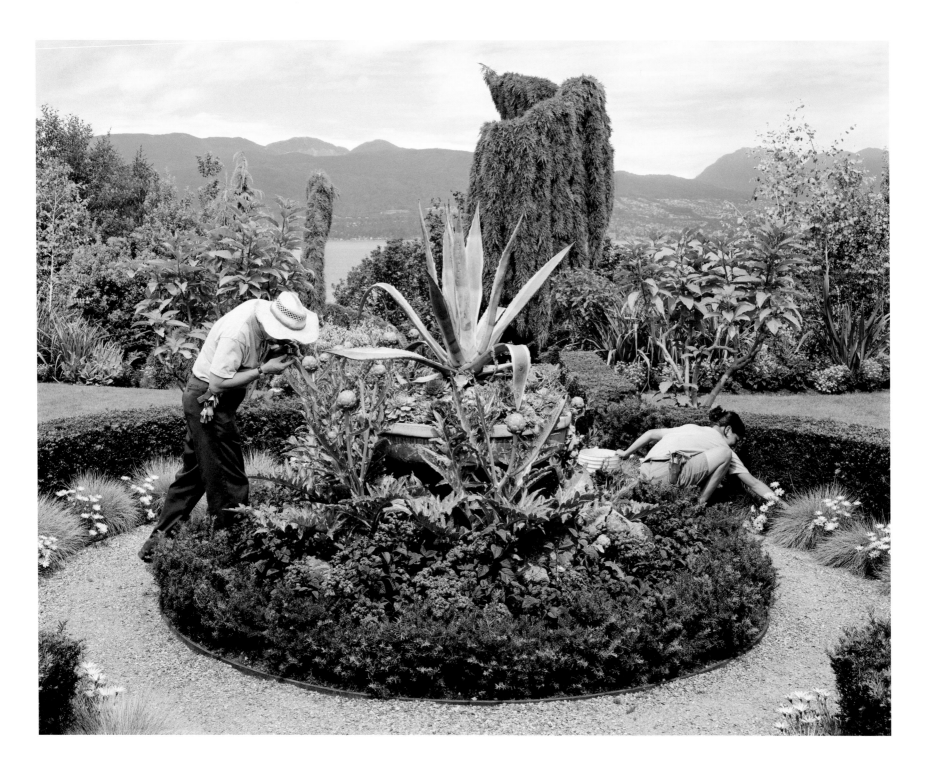

identified as an "art of describing," a mode of image-making that emphasizes the depiction of material surfaces over the rationalized order of Cartesian perspective or the ocular chaos of the baroque.[7]

McFarland began to use digital processes shortly after his work appeared in *After Photography*, scanning multiple exposures of a given scene and combining them to produce an apparently seamless final print. Initially the appearance of these new photographs did not depart radically from that of his earlier analog images. McFarland continued his depictions of private gardens and the people who maintain them, often turning to the example of nineteenth-century painters such as Gustave Courbet or Jean-François Millet to pose and position human figures, much as he had in his earlier work. Indications the new prints were digitally produced could be found principally in their extraordinary tonal range and clarity that allowed the viewer's eye to move continuously over the image, its scrutiny of the scene unhindered by the limitations of single-exposure, analog materials. Although he abandoned the technical parameters upon which Arden had built the premise for *After Photography*, McFarland's emphasis on descriptive detail and the taxonomic character of his titles—which use an analytical vocabulary to convey details of the site and actions depicted in the image—maintained the affinity with the version of realism Arden had cited.

McFarland's ambition for these pictures was to "return the image as much as possible to its original appearance as seen by the human eye."[8] The desire to emulate human vision and McFarland's interest in the rustic find a parallel in the conception of naturalism in photography articulated in the late nineteenth century by Peter Henry Emerson. Emerson, a physician who studied medicine at Cambridge University, maintained that if photography was to attain the status of art, practitioners must adopt a naturalistic approach closely modelled on human vision to reflect the artist's spontaneous impression of the natural world, an approach exemplified in his photographs of peasant life on the marshes of East Anglia. Images such as McFarland's *Inspecting, Allan O'Connor Searches for Botrytis cinerea* (2003) recall Emerson's attempt to replicate sight

Inspecting, Allan O'Connor Searches for *Botrytis cinerea*, 2003

through complete control over the tonal values of his prints. At the same time, the relentlessly crystalline detail in which McFarland represents every leaf, stem and petal is at odds with Emerson's insistence that photographs, like the human eye, have a distinct zone of optimal sharpness, with the surrounding areas rendered in softer resolution, and the taxonomic nature of McFarland's titles evokes the oscillation between the scientific and the poetic that has framed perceptions of photography since its inception and that ultimately led Emerson to abandon photography in 1890, declaring it a limited art form.[9]

Beginning in 2003, McFarland expanded his methods of picture-making to include strategies that made no effort to emulate human vision and overtly countered the traditional association of the photograph with a unique temporal moment. In *Torn Quilt with Effects of Sunlight* (2003), for example, a careful examination of the image reveals inconsistencies in lighting that point to a process in which a number of exposures from different moments of the day have been assembled into an image structured in the same way a quilt is pieced together. The sense of duration embedded in *Torn Quilt* becomes much more explicit in works such as *Orchard View with the Effects of the Seasons* (Variation #1) (2003–2006), an image of an abandoned orchard that was printed from a combination of exposures of the same view made over a period of years at different points in the annual growing cycle. Here the aberrant assemblage of a blossoming apple tree, an unkempt wisteria vine in full flower and a cherry tree about to drop its autumn foliage makes the separation of the photographic image from a single point in time immediately apparent.

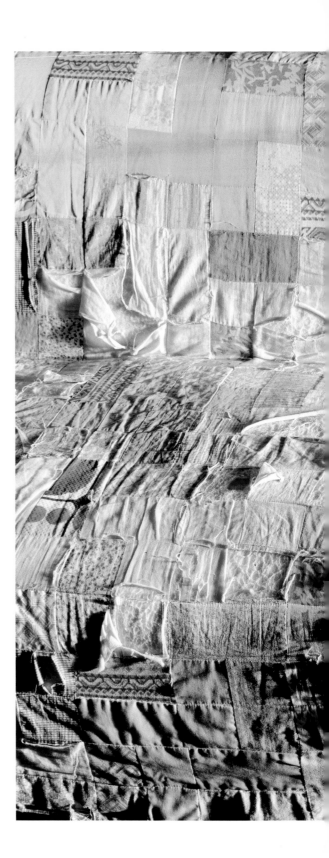

Torn Quilt with Effects of Sunlight, 2003

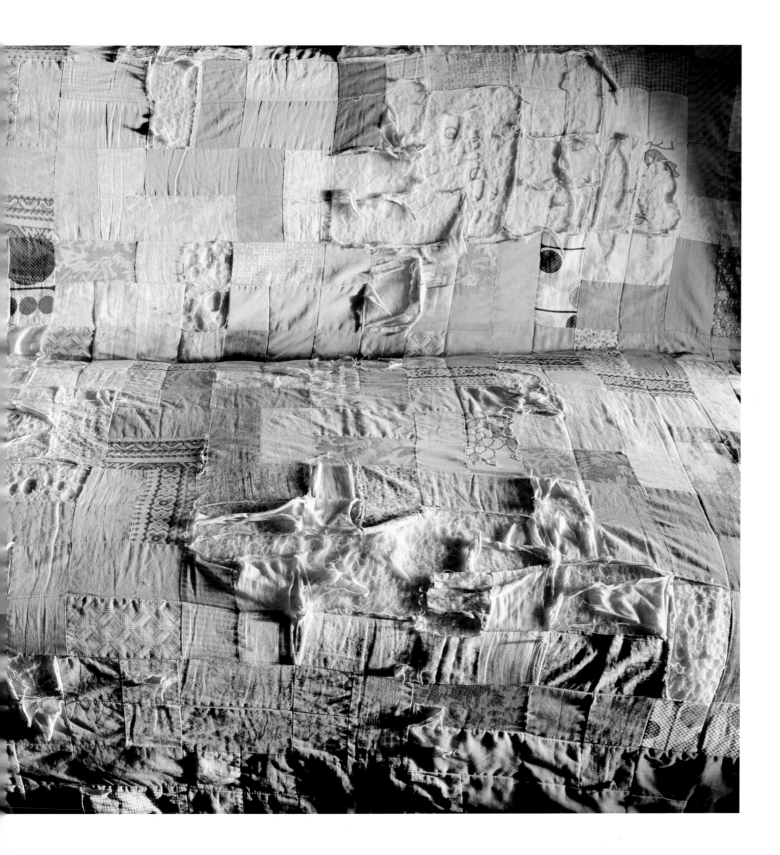

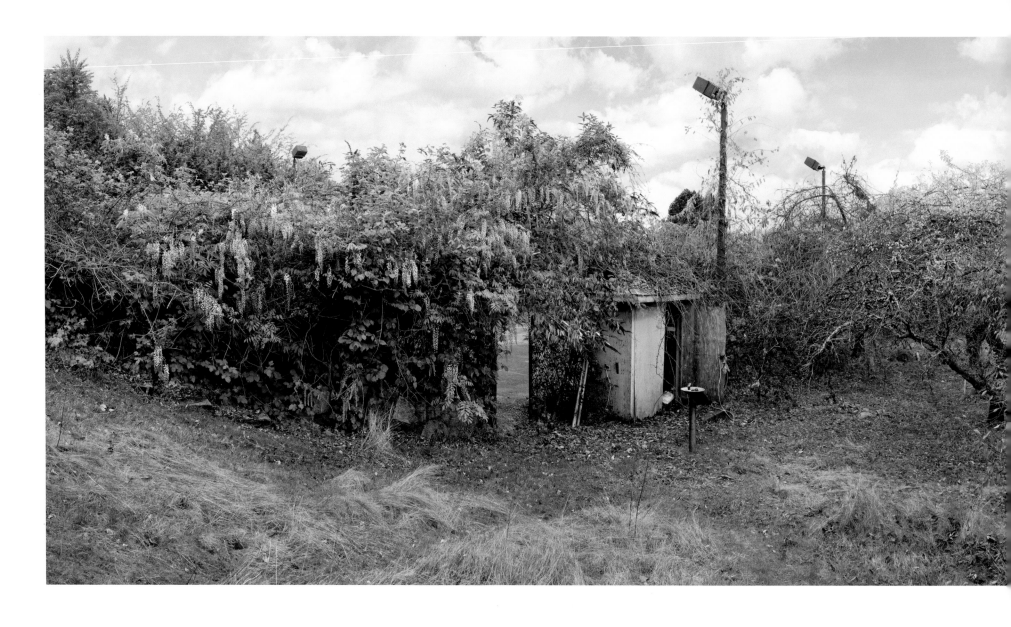

Orchard View with the Effects of the Seasons (Variation #1), 2003–2006

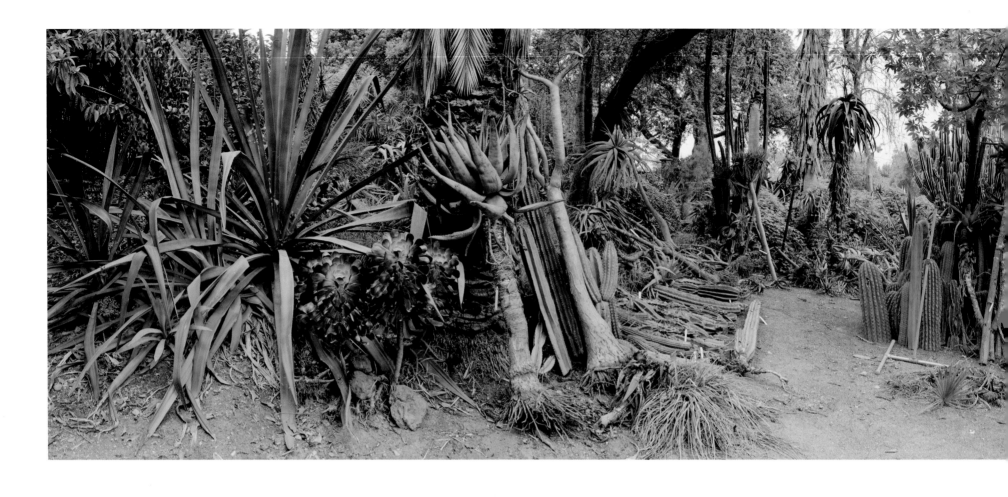

Huntington Botanical Gardens, San Marino, California. Desert Garden Nursery with
Succulent Collections Donated by Virginia Martin and Seymour Lyndon, Spring 2005, 2005

McFarland's more recent projects maintain his focus on staged versions of
nature and their relationship to photography, while also extending the scope
of his subject matter to include sites intended to entertain the public. These
include *Empire,* a body of photographs that depict the desert section of the
Huntington Botanical Gardens in San Marino, California. *Empire* comprises
a large-scale panorama depicting a range of succulents in the garden's nurs-
ery, along with a number of smaller-scale studies of individual plant species.
Emphasis on patronage is prominent at the Huntington Botanical Gardens,
which are part of a larger complex that includes a library and art museum,
founded in 1919 by Henry E. Huntington, a railway magnate and real estate
developer, nephew of the robber baron Collis P. Huntington, and the principal
architect of development in the Los Angeles basin during the early twentieth

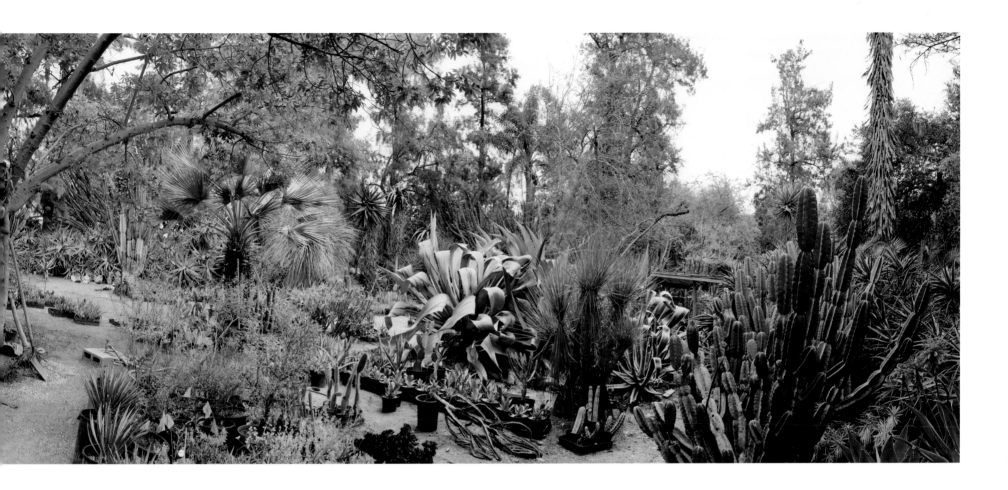

century. If the garden as subject matter operates as a corollary for the activity of making a photograph, the title of McFarland's *Empire* panorama, *Huntington Botanical Gardens, San Marino, California. Desert Garden Nursery with Succulent Collections Donated by Virginia Martin and Seymour Lyndon, Spring 2005* (2005), with its formal acknowledgement of the patronage that provided the garden with these particular botanical specimens, implies that the metaphor can be extended to encompass the activity of collecting and the quest for authenticity in which it is entangled.

McFarland's *Empire* photographs present a site in which concentrated arrangements of agave, yucca, aloe and euphorbia flourish in an apparently ideal California landscape. The plantings are dense and the soil is mostly hidden beneath the thriving vegetation, the fullness of the planting continually reminding the visitor of the fullness of Huntington's beneficence. In McFarland's *Echinocactus grusonii* (2006), the globular forms of dozens of golden barrel cacti draw our eyes back into the space of the photograph towards a stand of yucca and aloe plants, the bright yellow spines of the barrel cacti glowing in the perfect California sun. This sense of perfection dissipates as we notice the shadows of the cacti on the left side of the image fall in a different direction from those on the right. The constructed nature of the photograph becomes evident fairly quickly, and the image begins to oscillate between the pastoral and the comic, its almost campy staging verging on parody of the Edenic character the image of California so insistently calls up.

Hampstead Reservoir Observatory at Lower Terrace, near Whitestone Pond (edition 4/5), 2006

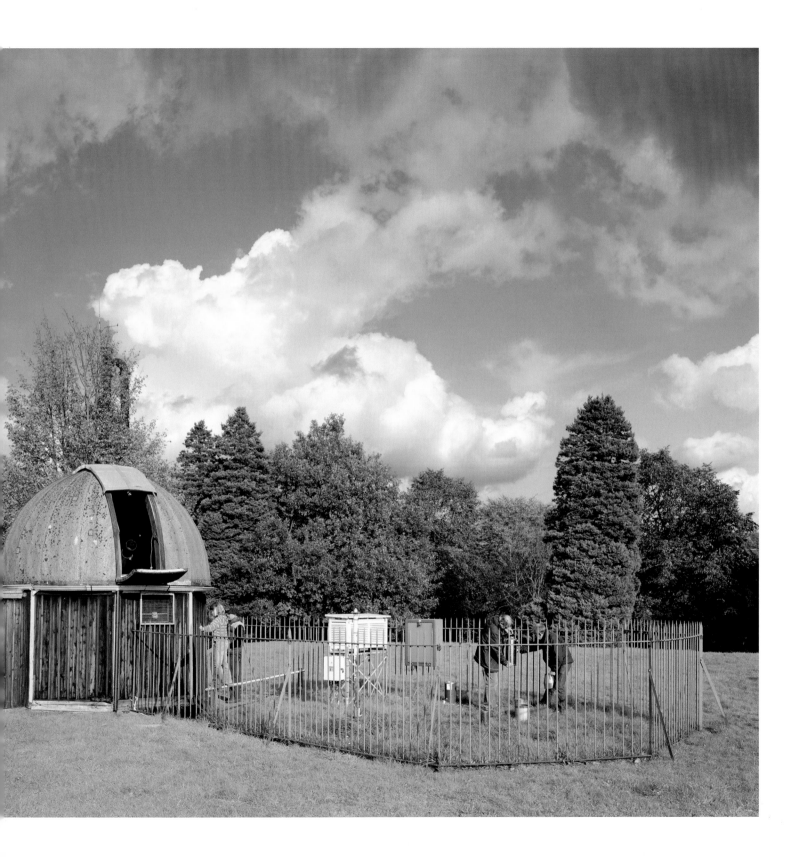

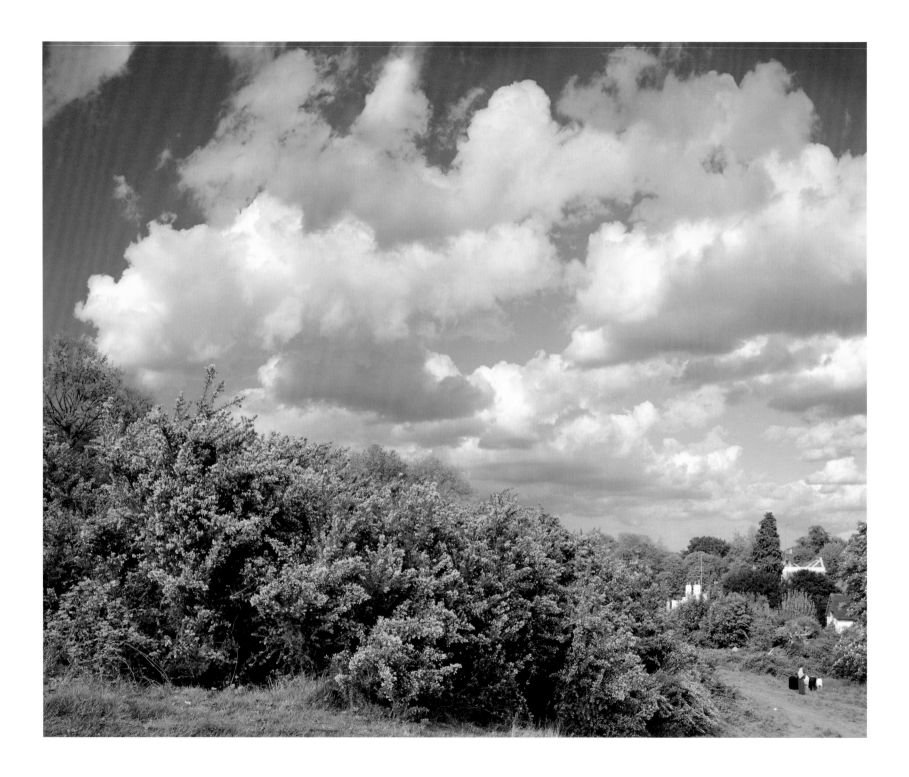

Several of McFarland's most recent projects are consciously situated in relation to pre-photographic representations of the sites he depicts. His approach to photographing Hampstead Heath has developed specifically in response to the paintings of John Constable, who made Hampstead the primary focus of his later work. Taking the continually changing effect of weather as a primary theme, Constable produced a large number of *plein-air* sketches of clouds at Hampstead, often including precise, semi-scientific notations on the time of day, direction of wind and other details of the weather. He also painted a number of studies depicting a particular view under different weather conditions. Constable was not aware of the early experiments in photography undertaken during the 1830s by Talbot, and he died two years before Talbot's invention of the calotype was made public. Nonetheless, what Geoffrey Batchen has described as a "photographic desire" can be seen in the emphasis Constable placed on descriptive detail, the seemingly arbitrary compositions of his cloud studies and his reinvention of one of Albrecht Dürer's *machines à dessiner* (of which Constable had no prior knowledge) to assist in the construction of perspective.[10]

McFarland's Hampstead images parallel his views of Vancouver gardens, in the staged rusticity that pervades both locations, as well as the rarefied price of real estate and the elevated economic status of its inhabitants. Art historian Ann Bermingham has linked Constable's Hampstead paintings to a shift in the perception of landscape that accompanied the rise of the English suburb in the early nineteenth century, when land came to be seen as both capital to be exploited and scenery to be enjoyed. Bermingham notes that "the fetish of rusticity" in the early Victorian suburb was linked to an "ambivalent relationship to the city" on the part of the upper-middle class and an anxiety towards the deprivations associated with the rapid modernization of urban life that accompanied the Industrial Revolution.[11] In the parallels drawn between Hampstead Heath and the expansive gardens of Vancouver's more affluent districts, McFarland's photographs seem to propose that this anxiety and the aesthetics associated with its amelioration are both quite durable.

Gorse and Sky (edition 1/5), 2008

Leafy emblems of nature recede into the background in McFarland's photograph *The Granite Bowl in the Berlin Lustgarten* (2006), which depicts a granite monument adorning the grassy expanse of a public pleasure garden on the Museumsinsel in the centre of Berlin. Viewing the image, we are separated from the immense stone bowl by a girl and boy, slim, blond and in the early stages of adolescence, their gaze drawn to something outside the picture's frame. Flanking them are the basic elements of the bourgeois family: to our left a mother attends to a baby in a stroller, on our right the jacketed arm and wing-tipped shoe of an adult male protrude into the frame while his leashed dog looks off in the same direction as the children. Behind them, a young man slumps on a stone bench, his shirt pulled up over his head in an effort to cool down in the hot summer sun, and an older man, apparently of lower social status than the dog owner, naps in the cool shade of the monumental bowl. While the image is pervaded with the atmosphere of a leisure-filled summer afternoon, these figures exist in a peculiar isolation; in the absence of any shared focus of attention, their consciousness is dispersed. If the granite bowl is meant to mark a shared history or public identity, the figures that populate McFarland's image seem indifferent to its presence.

Over the past three centuries, the symbolically charged site of the Lustgarten has undergone a series of transformations in response to larger, sometimes cataclysmic historical events. Originally developed in the seventeenth century as a garden to supply vegetables to the City Palace, it was later used as a landscaped pleasure garden and a military parade square. In the early nineteenth century it was redesigned as a formal garden by Peter Joseph Lenné in conjunction with a series of projects intended to mark Berlin as the capital of a prosperous Prussian state that had regained independence in 1815 after a long occupation by Napoleonic troops. Lenné's design was intended to complement the classical architecture of the surrounding buildings, including Karl Friedrich Schinkel's Altes Museum, which housed the Prussian royal family's art collection and was opened to the public in 1830. Flanked by the palace, the city's Protestant cathedral, the Prussian army's arsenal and Schinkel's museum, the Lustgarten was at the centre of what Schinkel described as the "Athens on the Spree"

The Granite Bowl in the Berlin Lustgarten (after Johann Erdmann Hummel), 2006

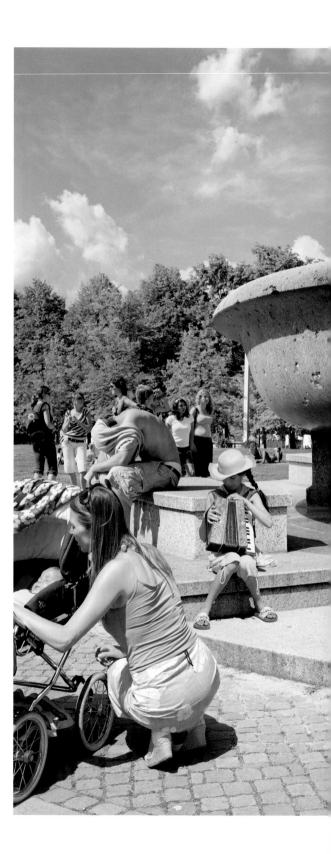

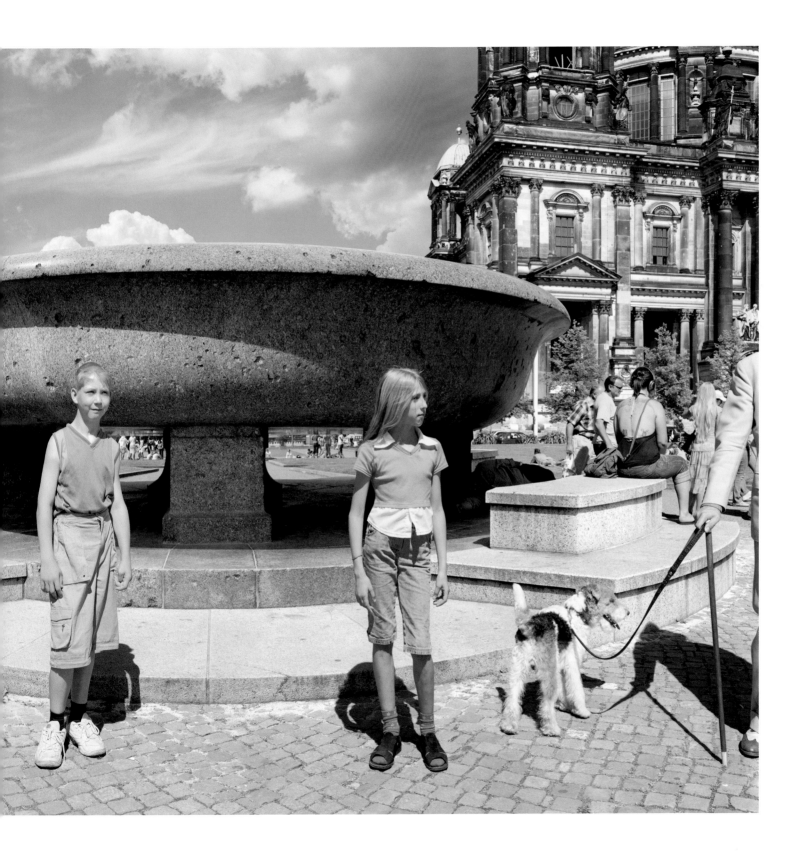

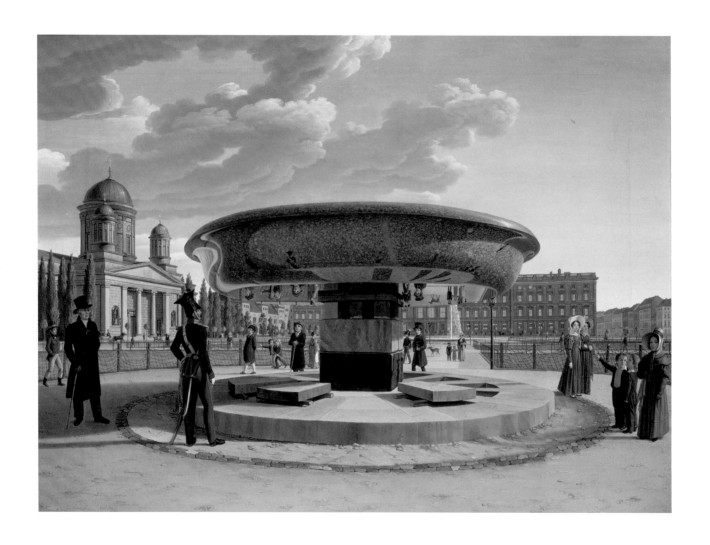

Johann Erdmann Hummel
The Granite Bowl in the Berlin Lustgarten, 1831
oil on canvas
66 x 89 cm
Collection of Nationalgalerie, Staatliche Museen zu Berlin

and "became the symbolic focal point of the [Prussian] state" during the Biedermeier era (1815 to 1848).[12] In the twentieth century, the space functioned as a site for mass demonstrations against the Nazi Party, which subsequently paved it over and used it for rallies at which Adolf Hitler addressed audiences of up to a million people. Heavily bombed during the Second World War, the Lustgarten was incorporated into the East German administration's plans to rebuild postwar Berlin as a socialist city in which, as part of the larger Marx-Engels-Platz, the site would function as "a grand square for demonstrations, upon which our people's will for struggle and progress can find expression."[13] It was re-established as a park along the lines of Lenné's design after German reunification in 1991.

The Lustgarten bowl was an ambitious and technically demanding commission. Seven metres in diameter, it was made from a single piece of granite dug up and hauled through the nearby Fürstenwalde forest by a crew of one hundred men in 1828, then transported by boat to Berlin where, for two years, it was ground and polished under the supervision of stonemason Christian Gottlieb Cantian. Pushing the technical limits of his craft, Cantian made the bowl larger than originally specified and as a result it could not be installed as intended in the rotunda of the Altes Museum. Nonetheless, the finished bowl was seen as a marvel of Prussian technological accomplishment, and citizens of Berlin made regular outings to the Lustgarten to contemplate their reflections in the bowl's polished surfaces.

The composition of McFarland's photograph is closely related to that of Johann Erdmann Hummel's painting *The Granite Bowl in the Lustgarten, Berlin* (1831), which depicts the bowl on temporary supports prior to its formal dedication in 1834. Hummel (1769–1852), whose career chronologically coincides with Constable's, was a progenitor of Biedermeier realism, which, in painting, emphasized precise observation and simplicity while downplaying brushwork as a mark of the artist's hand. A professor of optics at the Royal Academy of Art in Berlin, Hummel had a deeply held interest in rendering perspective, and the new buildings and monuments that exemplified the prosperity and

progressive character of the expanding city provided the perfect subject matter through which to demonstrate his mastery of perspectival technique. Hummel completed two paintings of the granite bowl: in addition to his depiction of the bowl newly installed in the Lustgarten, he painted it in production, as its surfaces were being polished to a mirror-like finish. Both scenes presented a difficult set of problems in their meticulously detailed rendering of the complex curvature of the bowl as well as the almost surreal, distended images of the surrounding space as reflected in the bowl's smooth surfaces.[14]

Like Constable, Hummel has been cited as a proto-photographic artist whose work was shaped by a broader confluence of cultural forces that emerged in the eighteenth century and brought the very nature of representation into question. Heinrich Schwarz has argued that these artists prefigured the way the world would be perceived through photography in their emphasis on "not only the richness of details which the camera would record indiscriminately, but also the segment which seems confined to the mere unchanged rendering of the unarranged image as it is caught by the visual pyramid."[15] McFarland's picture of the Lustgarten bowl, then, can be seen as a re-examination of that photographic desire from a time when the conception of the photographic that lay at the heart of that desire has been transformed into something that is yet to be clearly defined.

Consideration of McFarland's photograph in relation to Hummel's painting calls to mind Boris Groys's observations on the way photography has transformed the nature of labour in art-making. Noting "the artist's body no longer hinders the methodological or technical repetition of his efforts," Groys asserts that "the artist's eye is . . . freed from his body; a pure gaze, it no longer 'works' but merely decides, selects and combines . . . The photo-artist stands in the same relation to the modern company employee and his data-processing activities as the painter-artist in earlier times did to the factory worker and his manual labour."[16] Further, he argues the technology of photography has radically altered the relationship between the work of the artist and the work of the viewer/collector.

The artist is no longer a labourer—not even a privileged one—but has begun to observe the world through the master gaze of the collector. This transformation is revealed particularly clearly in the altered status of the artist as regards the "time economy of the gaze." The fact is that the massive investment in work, time, and energy needed for the creation of a traditional work of art was irritatingly out of all proportion to the terms under which the art was "consumed": after the artist has worked hard and long at his work, the viewer could "consume" it effortlessly at a glance . . . Only as a photographer does the artist place himself on an equal footing with the collector, as he, too, is now able to produce pictures at an instant, with the simple click of the camera.[17]

On some levels, a comparison of McFarland's method of production to that of Hummel's would seem to confirm Groys's argument. Hummel's painting required a high level of manual skill learned through an extended period of intensive training, as well as a thorough knowledge of orthographic projection and the arcane intricacies of its geometry, in order to accurately depict the bowl's complex curvature and the minutiae of its reflections of the surrounding space. Conversely, McFarland's photograph required little in the way of physical proficiency and he was liberated from the task of constructing the image through the systematic application of geometry by the camera's lens. Further, his citation of a range of landscape precedents and depiction of prosaic subject matter evoke Groys's description of the photographer as

> an exemplary observer, user, who observes, evaluates and takes in things that are produced by others . . . The innovative artist of today is not someone who produces things, but a person who finds aesthetic stimulus and interest in certain, already known objects that other people may perhaps find boring and uninteresting.[18]

On the level of time economy, though, Groys—writing in 1998, before the methods McFarland now deploys were in common use by artists—seems to overstate the level of equality on the part of the artist and the viewer/collector.

McFarland's photograph is not produced in an instant. Although the Lustgarten was reconstructed along the lines of Lenné's nineteenth-century design, the space is now quite different than when Hummel painted it, and McFarland's emulation of Hummel's composition required a great deal of computer manipulation. The image of the bowl is a composite of exposures made from four different positions, at different times of the day; a corner of the Berliner Dom, with its neo-baroque detail, has been positioned to stand in for the smaller neoclassical church of Hummel's painting, and the figures that populate the image were shot over a period of weeks. Although McFarland's work preserves the shift from the hand to the disembodied eye as the principal locus of creativity that photography initiated, and the time involved in creating this image is a choice rather than necessity, the painstaking and meticulous stitching together of the various exposures to some extent revokes the egalitarian balance between the time of production and the time of consumption Groys identifies.

Hummel's painting provides us with a view that looks south across the Lustgarten towards the Royal Palace, with the recently finished granite bowl directly in the centre of his composition. The viewer is positioned on the edge of a circle of spectators that includes a Prussian soldier and a well-dressed gentleman on the left and some upper-middle-class women and children on the right, who gaze and point in fascination at their reflections on the smooth underside of the massive bowl while figures from a variety of social positions tranquilly stroll the sandy paths in the background. Lengthening shadows indicate late afternoon; the play of sunlight on the portico of the relatively modest Protestant cathedral and the gently billowing clouds that drift across the eastern sky contribute to a sense of ordered harmony.

For Hummel's nineteenth-century Prussian audience, this scene would have presented a tangible image of a modern nation that had attained its elevated status through organization, discipline and the rule of law. The rigorous simplicity of Hummel's painting, in which the natural law of geometry was used to represent the marvels of the Lustgarten bowl in accurate perspective, would have confirmed both the validity of this image of the state and the role of empirical inquiry in measuring the truth of the world.

Ruinberg, near Schloss Sans Souci, Potsdam (edition 2/5), 2006

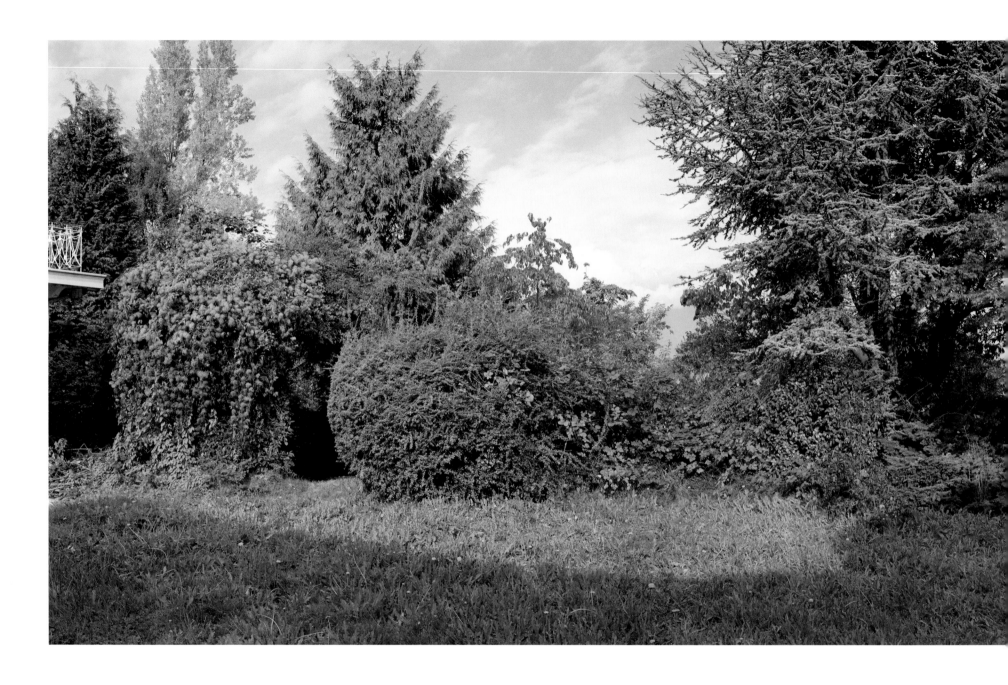

Fountain Study, Late Fall; *Cedrus atlantica, Acer palmatum, Populus nigra,* 2004

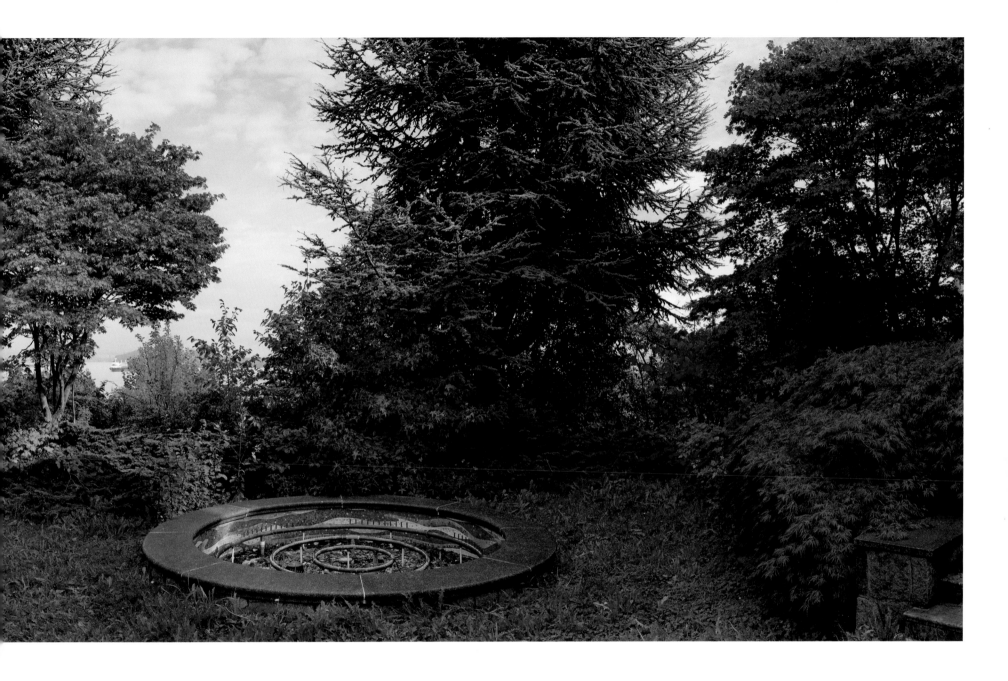

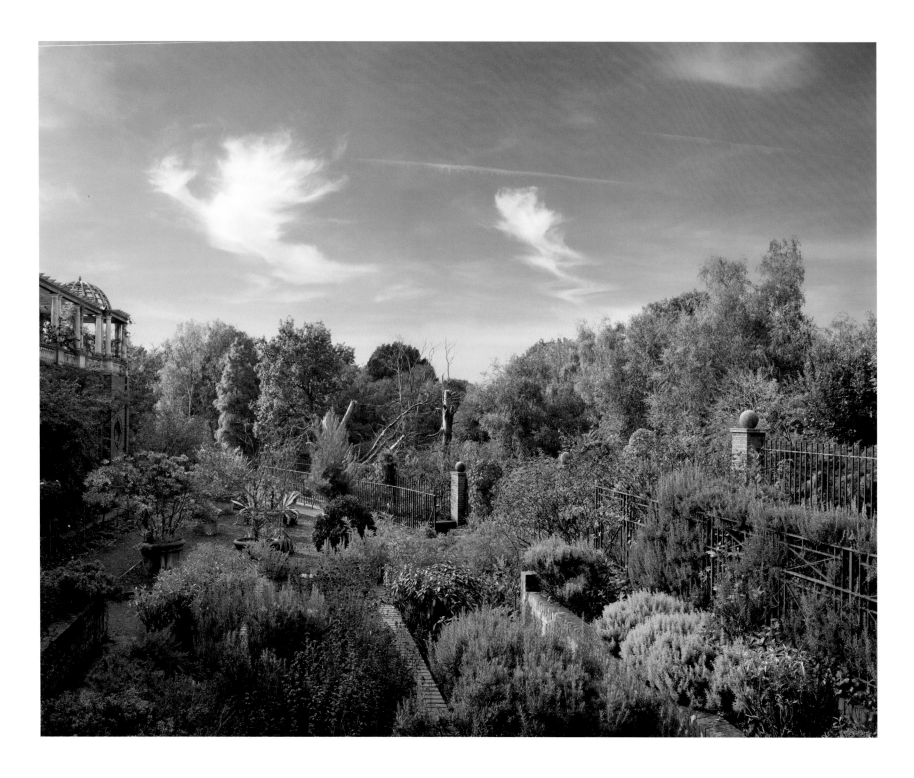

In McFarland's photograph, the granite bowl sits lower relative to the viewer than in Hummel's image. For the viewer and most of the depicted figures that surround the bowl, the granite bottom is outside their field of view. Even if it were visible, it seems unlikely it would attract the attention represented in Hummel's painting. The gleaming surface of the bowl, which allowed Hummel to display his virtuoso ability in rendering perspective and which fascinated throngs of nineteenth-century strollers in the Lustgarten, has disappeared. The bowl is now weathered, pockmarked with bullet holes and cracked; its potential for spectacular reflection of nationalist power is exhausted. The bowl's diminished capacity to mirror is reiterated for the viewer as discrepancies in the image become apparent—such as the different directions in which the shadows of the two adolescents in the foreground fall—and the sense of empirical truth attached to the photograph deflates with its initial impression of seamlessness. The bowl has a lumpy, cumbersome presence, and even on an idyllic summer afternoon its mass contrasts sharply with the slender limbs of the adolescents. But, even if they look frail in relation to the bulk of the granite, their expressions and posture suggest a modest level of self-confidence, and their relationship to the bowl seems to be one of ambivalence rather than apprehension.

While McFarland's work leaves us in a state of uncertainty, its engagement with the history of the photographic and its development as a reproductive technique attest to the persistence of the desire to ground knowledge of the world in the description of its surfaces. Pursuit of the real is not denied in McFarland's images; on the contrary, they rely on the viewer's attempt to measure the image against some idea of the authentic. If the real remains contingent, something slippery and impossible to grasp or fully represent, McFarland's work still summons our attention back to the point at which the world enters representation and the mechanisms that facilitate that process.

Hill Garden Pergola at Inverforth House (edition 4/5), 2007

1. Peter Henry Emerson, "Hints on Art," originally published in *Naturalistic Photography for Students of the Art* (London, 1889), reprinted in *Classic Essays on Photography*, ed. Alan Trachtenberg (New Haven: Leete's Island Books, 1980), 102.

2. Hubert Damisch, "Five Notes for a Phenomenology of the Photographic Image," originally published in *L'Arc* (Paris, 1963), republished in Trachtenberg, *Classic Essays on Photography*, 290.

3. Boris Groys, "The Promise of Photography," in *The Promise of Photography: The DG Bank Collection*, ed. Luminita Sabau (Munich: Prestel, 1998), 29.

4. William Wood, "To the Management," in *Scott McFarland*, by Scott McFarland and others (Vancouver: Contemporary Art Gallery, 2006), 25.

5. Roy Arden, *After Photography*, (Vancouver: Monte Clark Gallery, 1999), 2.

6. Ibid., 2.

7. Ibid., 4.

8. This was taken from a description of McFarland's work on the website of the Monte Clark Gallery in 2001.

9. Emerson came to this conclusion after encountering the research of the chemists Ferdinand Hurter and Vero Charles Driffield into the sensitivity of photographic emulsions, published under the title *Photochemical Investigations and a New Method of Determination of the Sensitiveness of Photographic Plates* in 1890. As Alan Trachtenberg has pointed out, Hurter and Driffield's "proof of an unchanging ratio of exposure, density, and development [crushed] Emerson's belief in the photographer's complete control over tonal relations in his works." See Trachtenberg's introduction to Emerson's "Hints on Art," in *Classic Essays on Photography*, 99–100.

10. Heinrich Schwarz, "Before 1839: Symptoms and Trends," in *Art and Photography: Forerunners and Influences, Selected Essays by Heinrich Schwarz*, ed. W.E. Parker. (Rochester: Visual Studies Workshop Press, 1985), 106–7.

11. Ann Bermingham, *Landscape and Ideology: The English Rustic Tradition, 1740–1860* (Berkeley: University of California Press, 1986), 166–67.

12. Brian Ladd, *The Ghosts of Berlin: Confronting German History in the Urban Landscape* (Chicago: University of Chicago Press, 1998), 54.

13. Ladd, *The Ghosts of Berlin,* 56.

14. Martin Kemp, *Visualizations: The Nature Book of Art and Science* (Berkeley: University of California Press, 2001), 60–61.

15. Schwarz, "Before 1839: Symptoms and Trends," 106.

16. Groys, "The Promise of Photography," 28, 31.

17. Ibid., 29.

18. Ibid., 30.

Boathouse with Moonlight, 2003

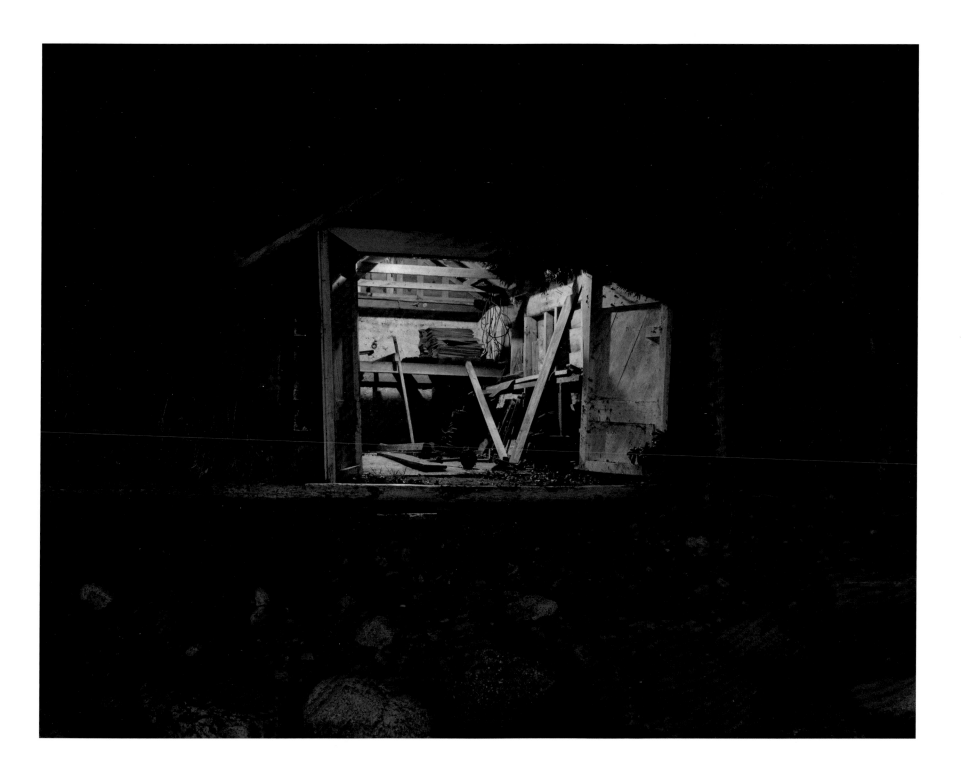

Corner, 2004

Bench, 2003

Coiled Wire, 2002

Driftwood, 2006

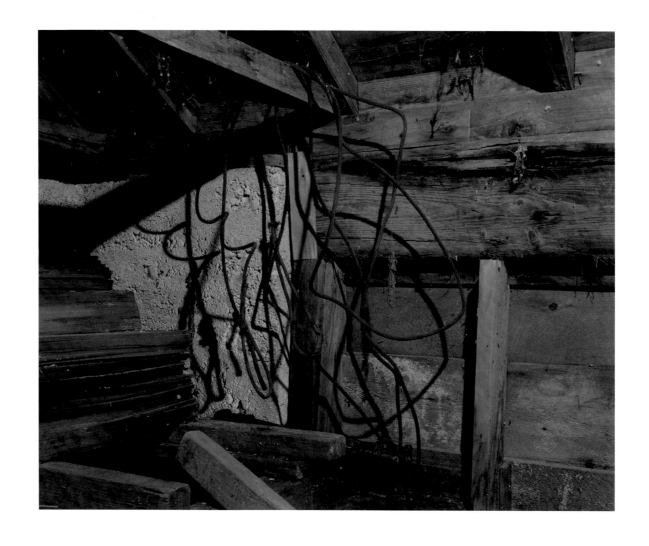

Wrapped Wire, 2003

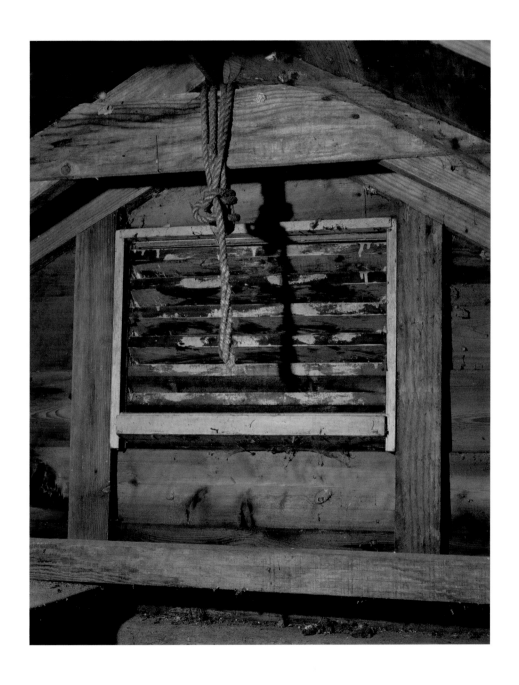

Rope, 2002

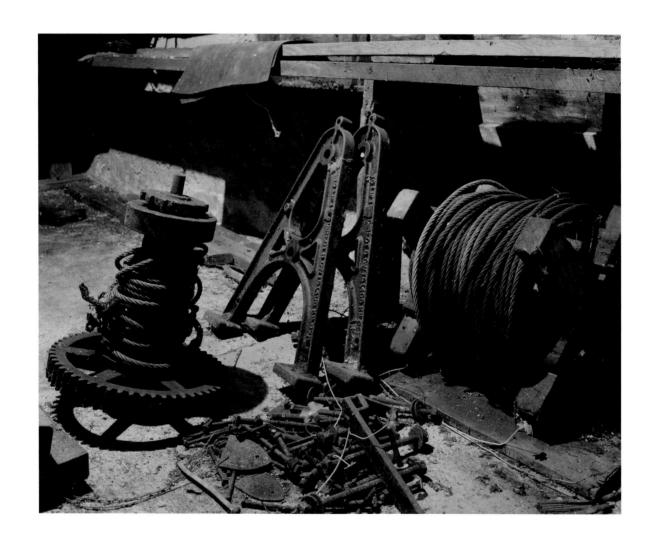

Winch, 2004

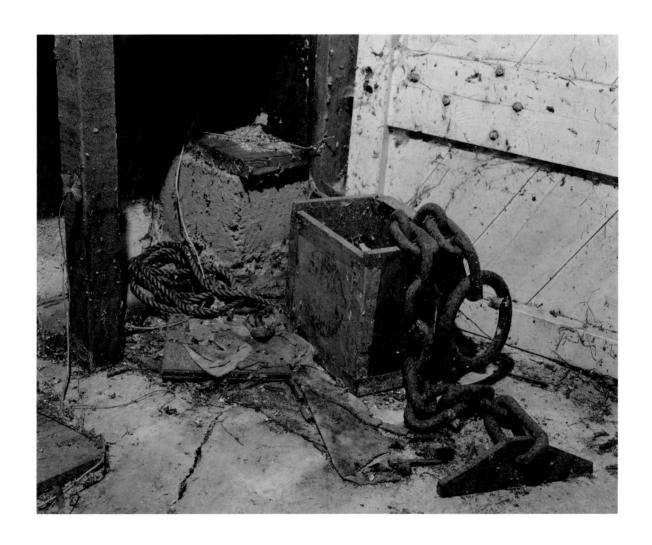

Anchor, 2006

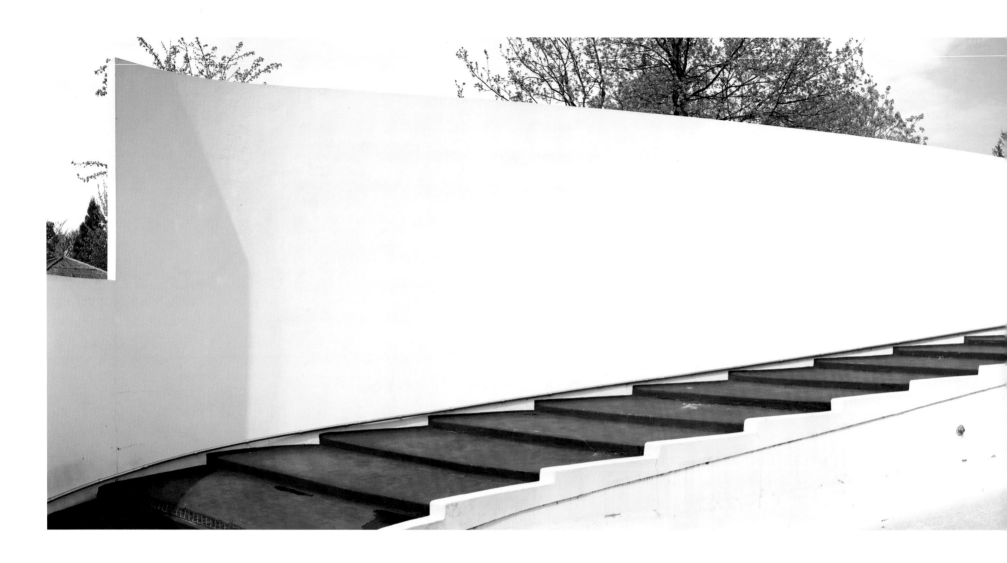

NEW HYBRIDS
Eva Respini

Emptied Penguin Pool, London Zoo, May 2008,
Architect: Berthold Lubetkin, 1934, 2008

Scott McFarland is a collector of sorts. He makes his pictures through a process of acquisition over time. Positioning his camera in a single spot, he rotates it slowly, making many exposures of sections of the same place. He then uses Photoshop to combine multiple exposures into an extremely sharp and detailed photograph that appears naturalistic, seemingly made in a single moment. McFarland is drawn to the built spaces of zoos and gardens and has returned to photograph these sites time and again. In his work, such spaces are a metaphor for the constructed photograph.

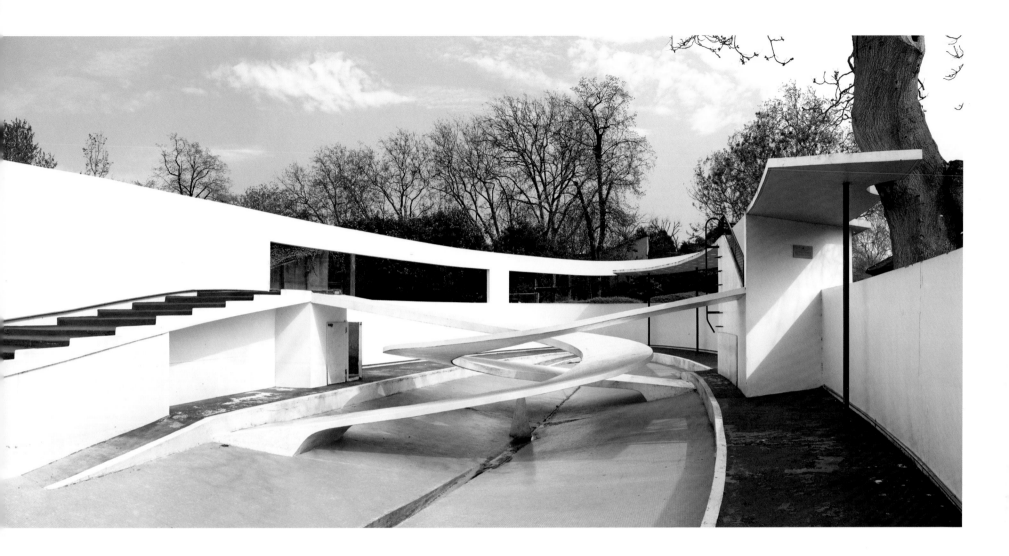

The advent of photography coincided with the proliferation of zoological gardens. As photographic innovators such as Louis Daguerre and William Henry Fox Talbot endeavoured to perfect their "light impressions" of the natural and social world, zoos developed as cultural sites that combined scientific curiosity with entertainment. Although zoos became preservation centres, these live cabinets of curiosities titillated viewers with a variety of exotic species. Botanical gardens, including those dedicated to scientific research, have existed for millennia, but the nineteenth and twentieth centuries saw the rise of pleasure gardens, which, like zoos, reflected the Victorian zeal for collecting.

It snowed on and off during the two weeks in 2006 when McFarland photographed the porcupine display at the Berlin Zoo. The dusting of snow on the rocks and animals' cave dwellings echoes the white-tipped quills of the porcupines. The zookeeper feeds the porcupines carrots—an orange flash of colour in an otherwise monochromatic picture—while a young family looks

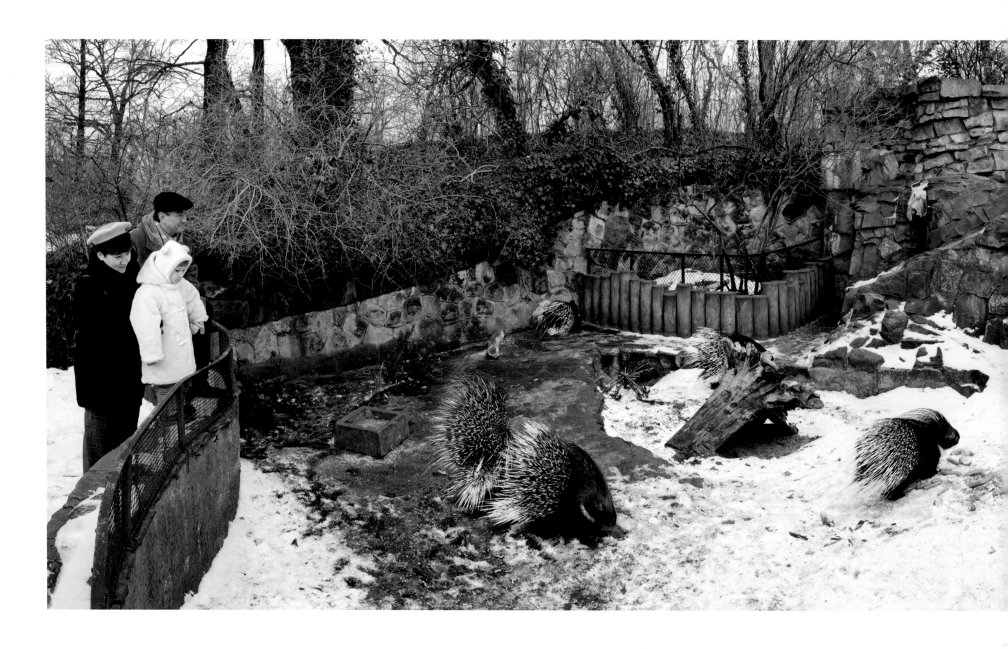

Display for Porcupines *(Hystrix africae australis)*, Zoologischer Garten, Berlin, 2006

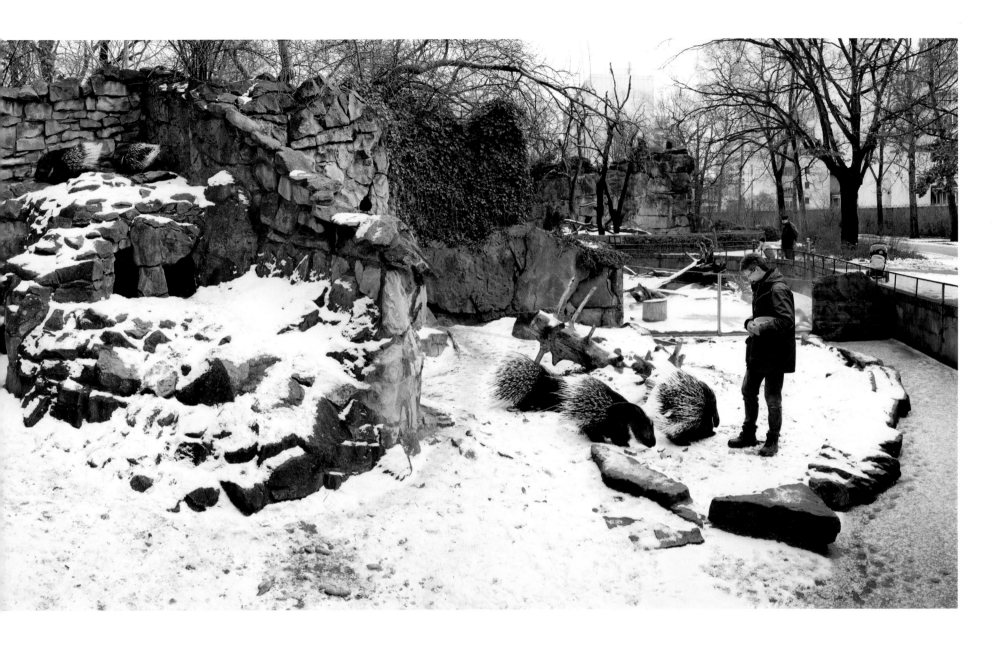

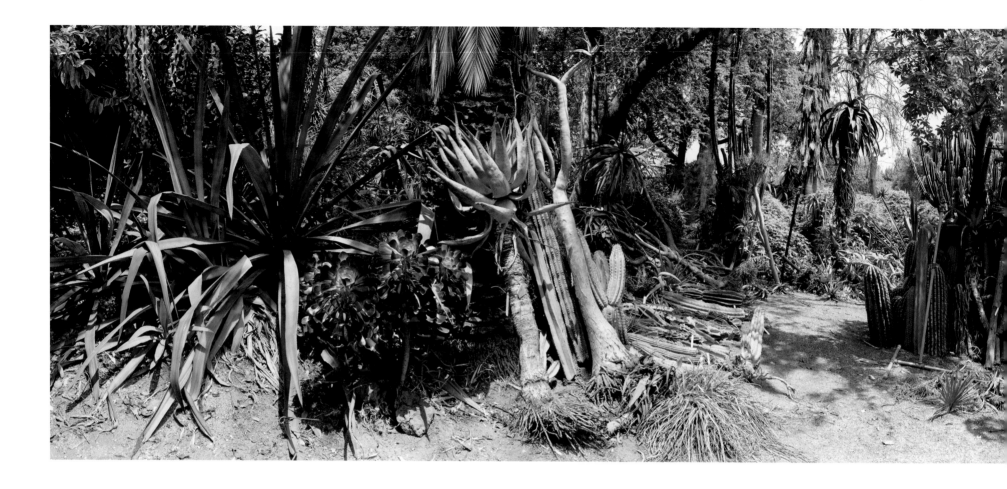

on, their ruddy-cheeked daughter wearing a hat decorated with animal ears. In this placid scene, the zookeeper's tender expression is evidence of a deep-rooted relationship between humans and animals in captivity. Perhaps the porcupines have never seen their native habitat; nocturnal creatures originally from Africa, they seem at home feeding at daytime during a grey Berlin winter. Here, a hybrid model for the natural world emerges, where nature and artifice are seamlessly intertwined.

In 2005 McFarland photographed the nursery of the Huntington Botanical Gardens over the course of several weeks. The nursery is the backstage, rarely seen by the public. Carefully tagged succulents and uprooted trees seem haphazardly placed here, in contrast to the careful presentation of the formal gardens. The unrelenting Southern California light is the opposite of the bleak

overcast sky of northern Europe, and the stark sunshine is as much a subject of the photograph as the plants. The inconsistent shadows and impossibly even sunlight on some flora give clues to the passage of time and the constructed character of the artist's digital images. Although the nursery is not maintained like the display gardens, it is nevertheless built and cultivated by man.

Over the past year McFarland visited the Penguin Pool at the London Zoo and made two panoramas of the display. Designed by Berthold Lubetkin in 1934, the Modernist concrete structure is distinctive for its cantilevered spiral ramps and elliptical pools. However, the glass-tiled pools and smooth concrete surfaces did not prove conducive to the birds' reproduction, which requires soft surfaces for nesting. In McFarland's photographs, it sits empty. McFarland's second version of the Penguin Pool evokes the cantilevered forms

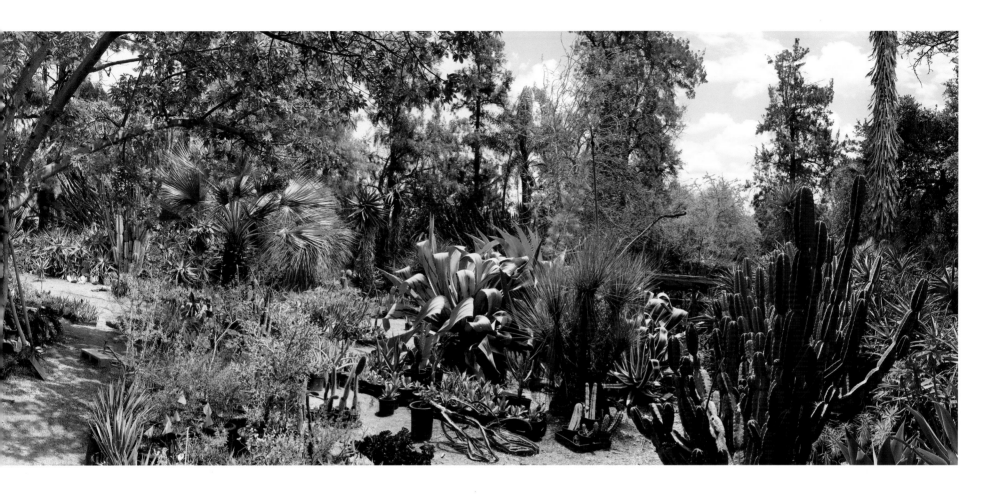

of Lubetkin's design in its construction of photographic space. As McFarland rotated his camera he did not level it between exposures, so that in his images the structure tilts, appearing distorted and elongated. McFarland completely forgoes the natural world in favour of rendering an architectural space where the human hand is evident. Devoid of animals and spatially distorted, this photograph speaks most directly to the translation of built spaces into the photographic realm.

The work involved in creating and maintaining the artificial environments of a zoo or botanical garden is mirrored in McFarland's art-making. Zookeepers and gardeners collect a variety of species from around the world to create displays that present a new natural form. Gardens showcase species that would never grow together, and zoos house animals far from their natural habitats.

Similarly, McFarland's pictures are visual inventions. Although they describe a space that truly exists, they compress moments in time to create unique representations of the world visible only in McFarland's photographs. The artificial is a hallmark of the digital era, when manipulation is the default rather than the exception. All pictures can be engineered with Photoshop, even if they appear to be straightforward documents or records. Of course, photographs have always been fictions. However, digital manipulation introduces new possibilities for the medium; images can be constructed rather than staged. With these pictures McFarland expands the traditional definition of the medium and champions a new hybrid form.

Huntington Botanical Gardens, San Marino, California. Desert Garden Nursery with Succulent Collections Donated by Virginia Martin and Seymour Lyndon, Spring 2005, 2005

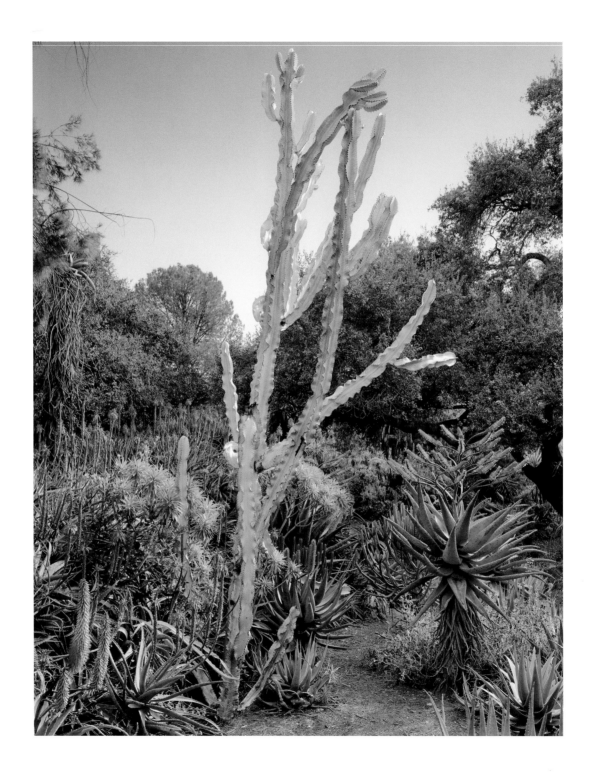

Euphorbia ingens, 2006

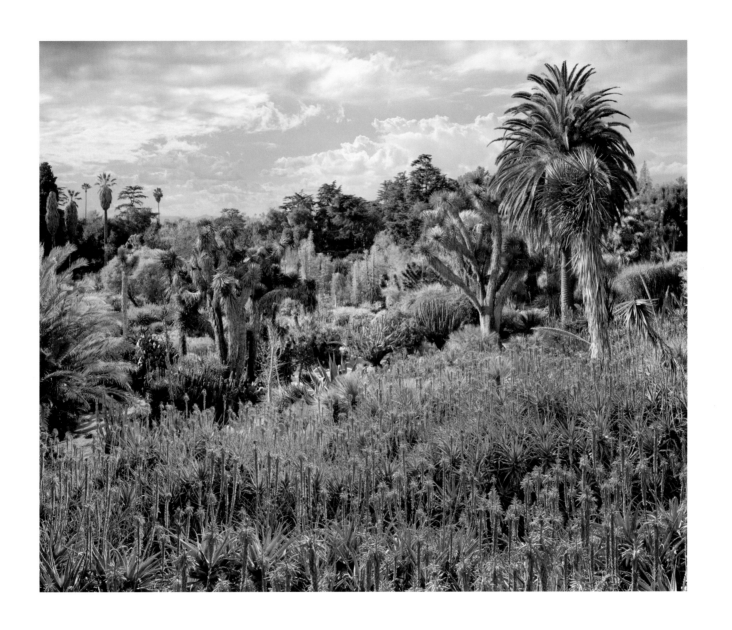

Yucca brevifolia, 2006

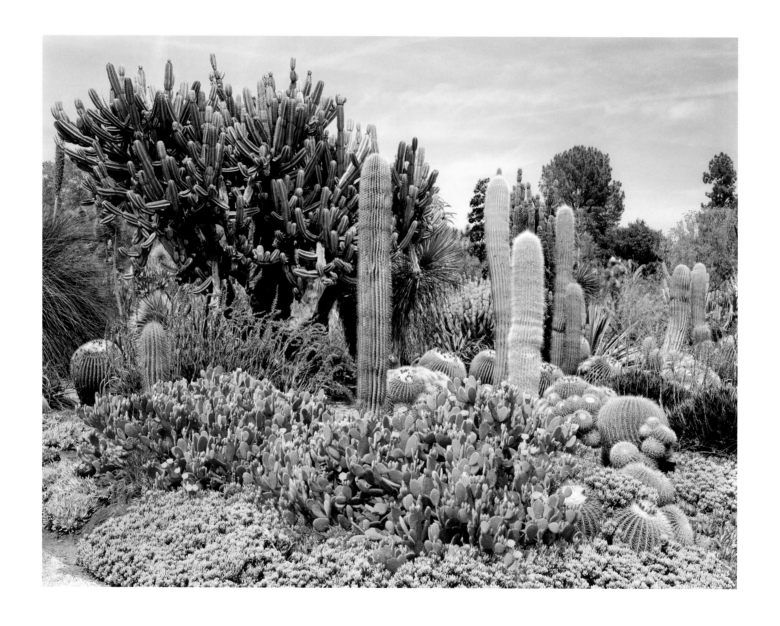

Opuntia microdasys, 2006

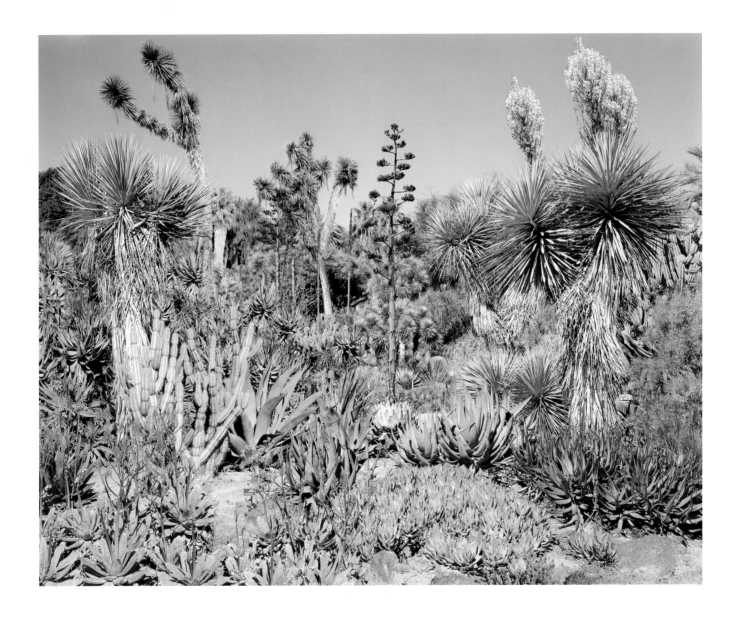

Aloe principis, 2006

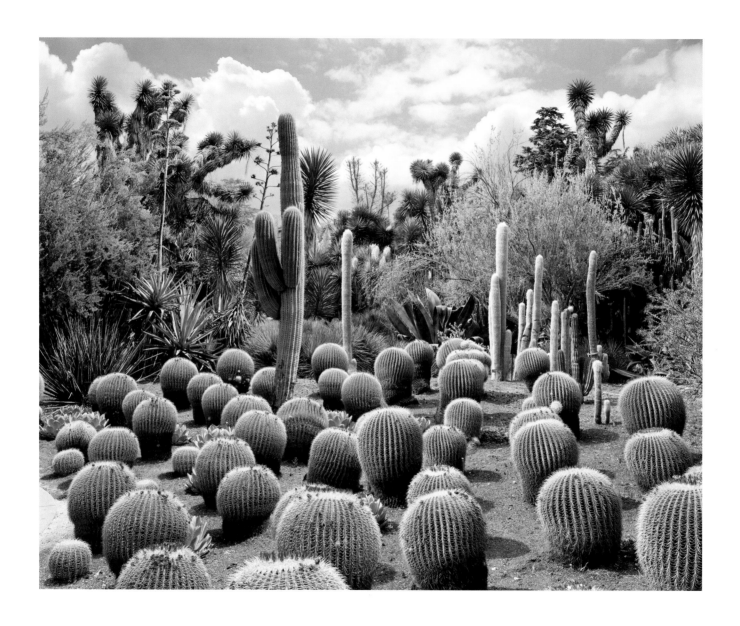

Echinocactus grusonii, 2006

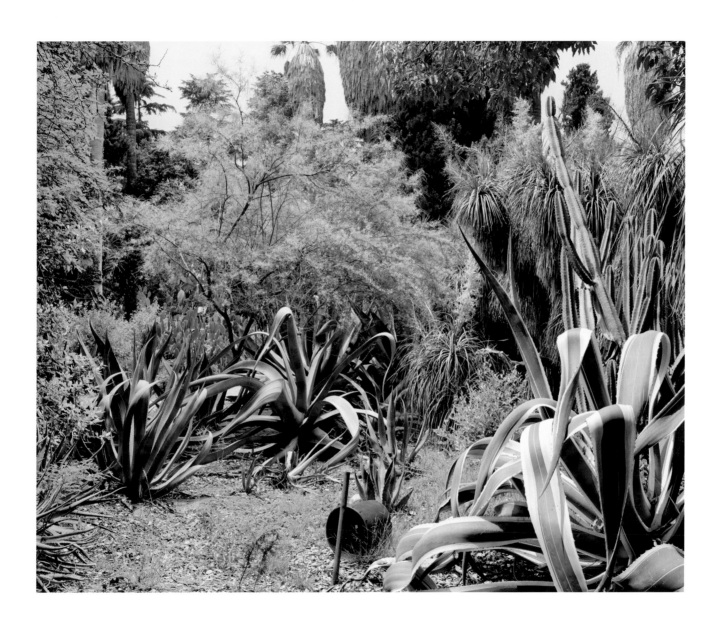

Agave americana variegata, 2006

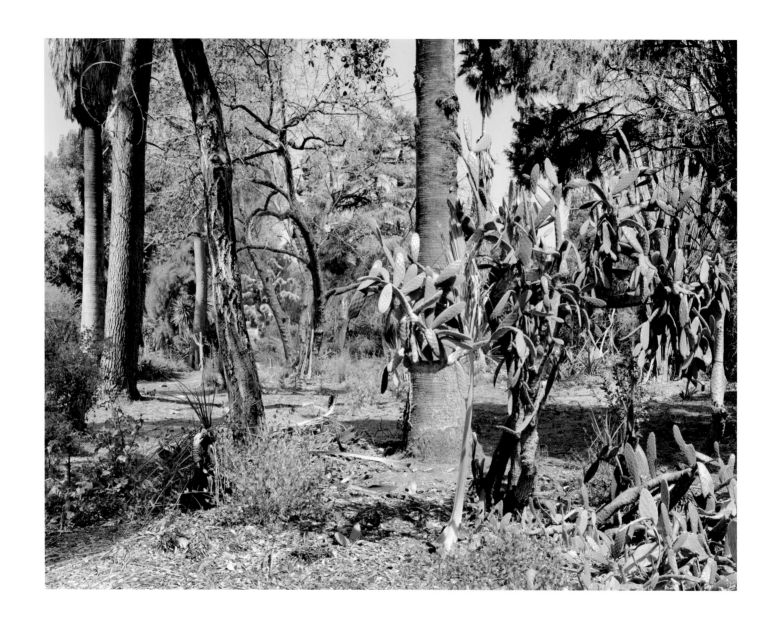

Washingtonia filifera, 2006

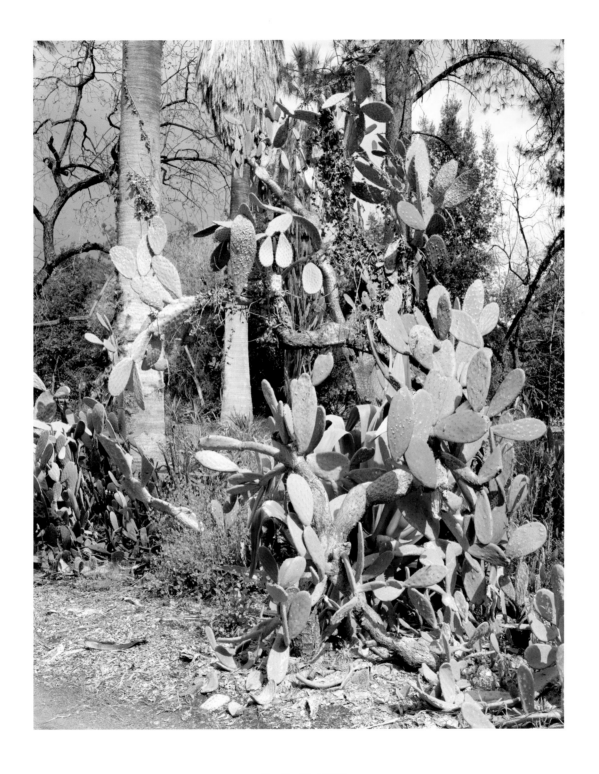

Opuntia pittieri, 2006

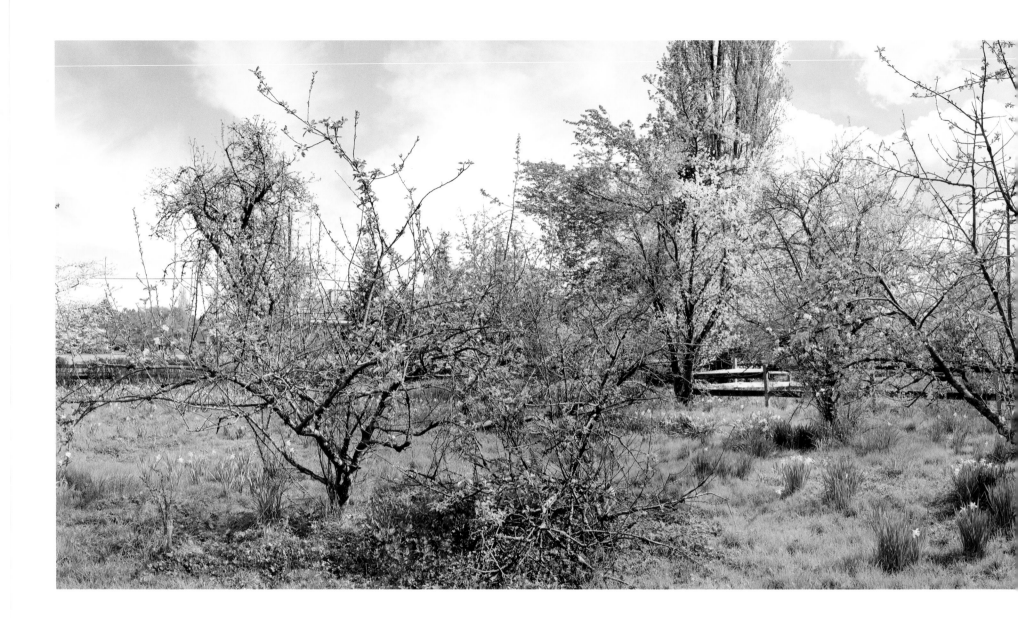

Orchard on Dr. Young's Property, 3226 W. 51st, Vancouver, 2005

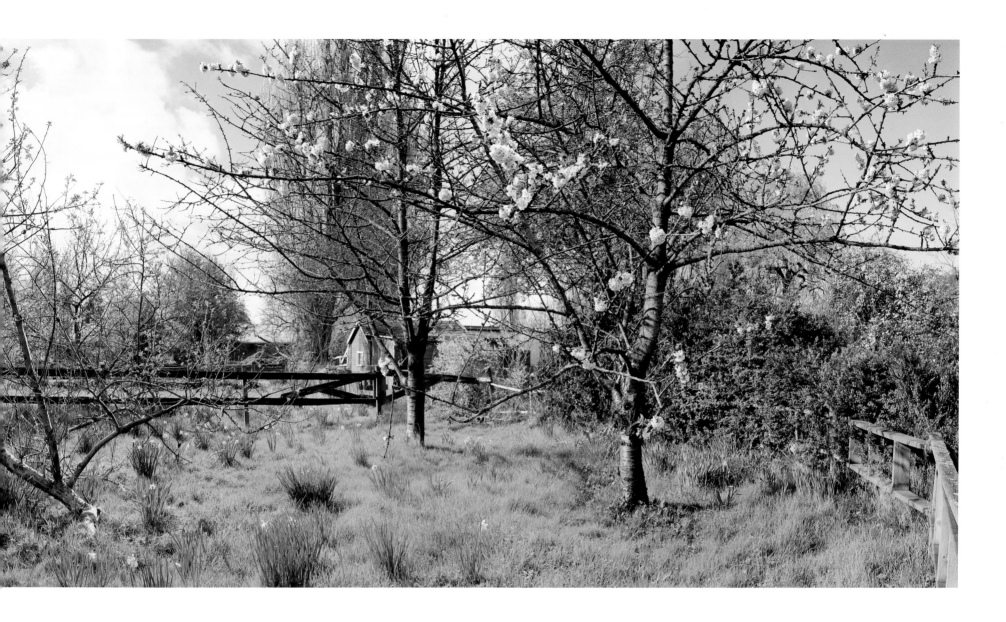

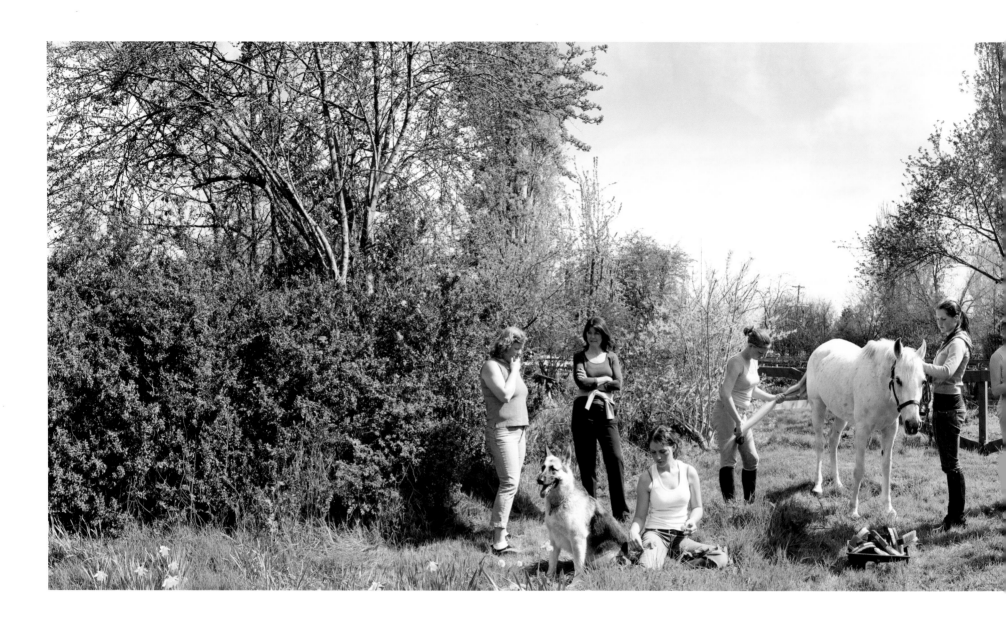

Stables on Dr. Young's Property, 3226 W. 51st, Vancouver, 2005

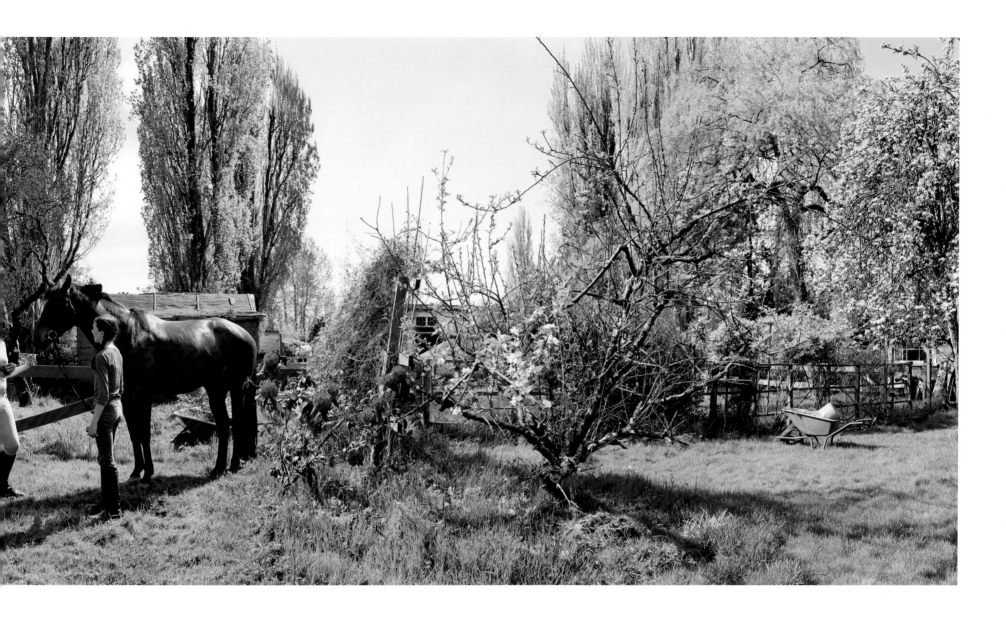

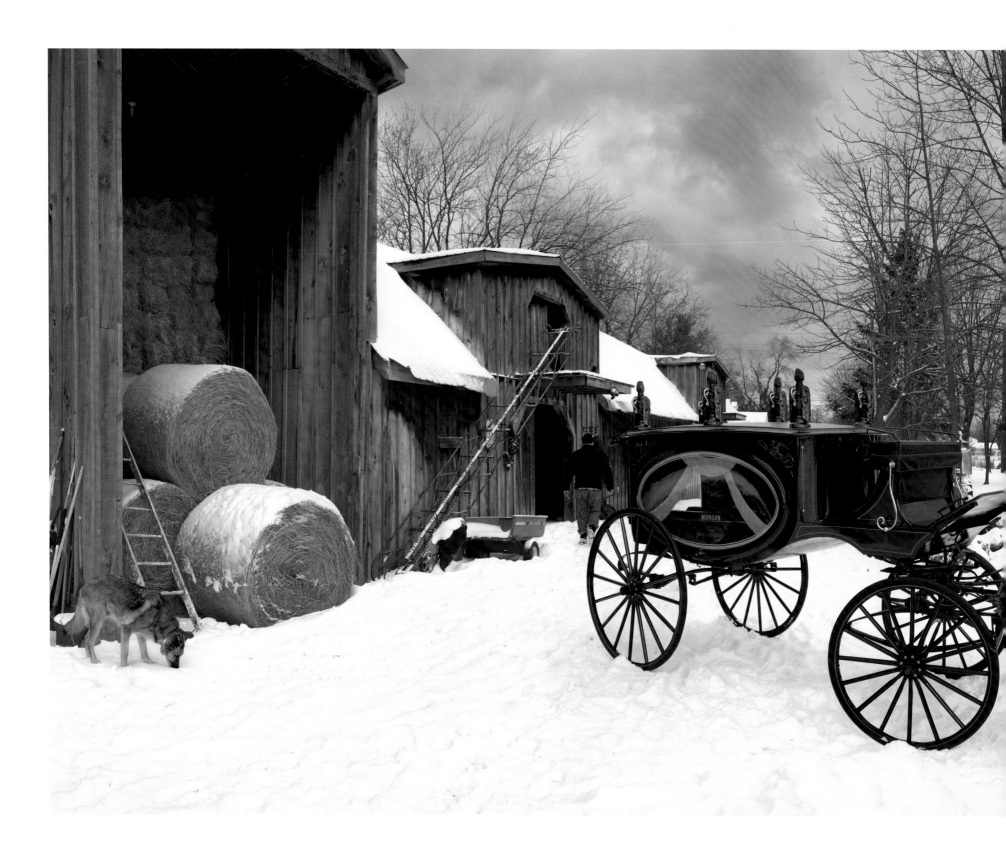

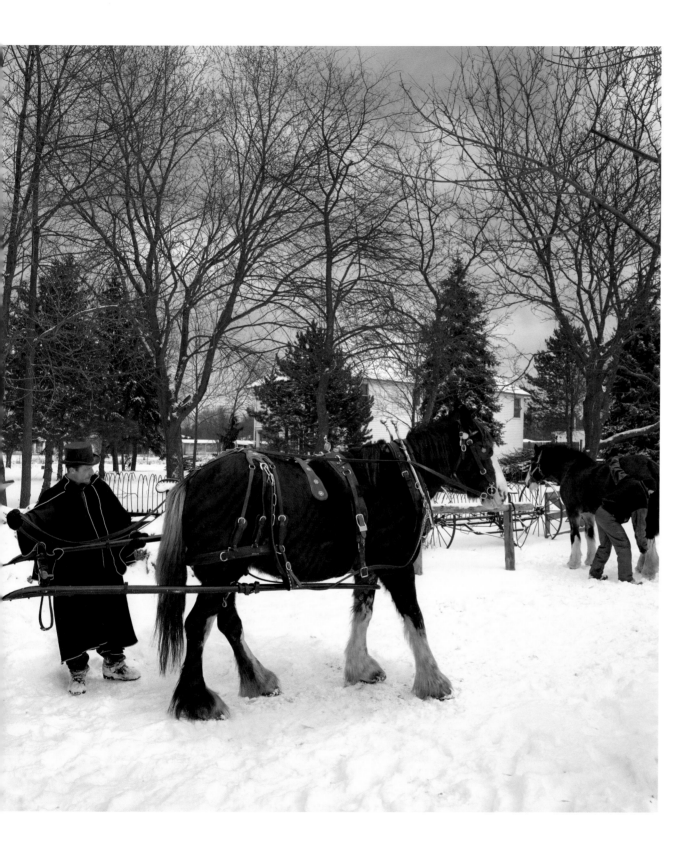

A Horse-Drawn Hearse, Queens Royal Tours,
174 Anne, Niagara-on-the-Lake, Ontario, 2009

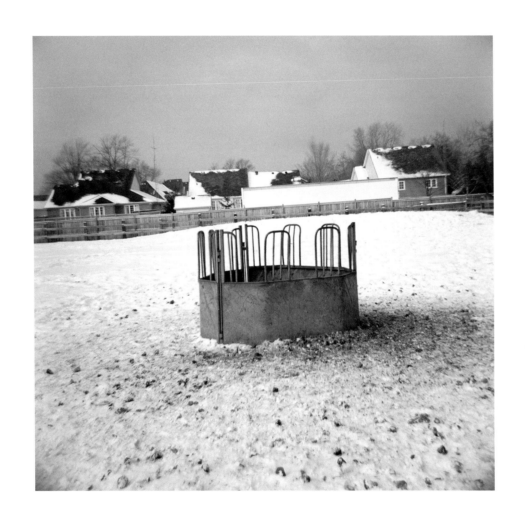

Feeder, 2009

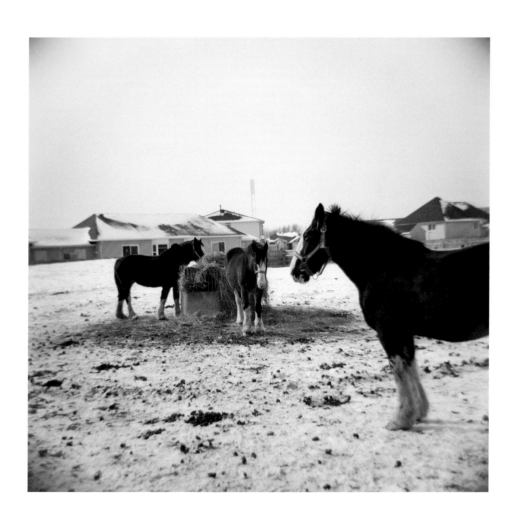

Marquee, 2009

Tractor, 2009

Model T, 2009

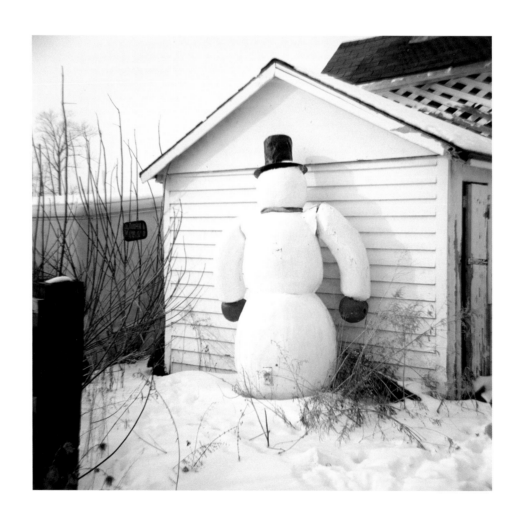

Snow Man, 2009

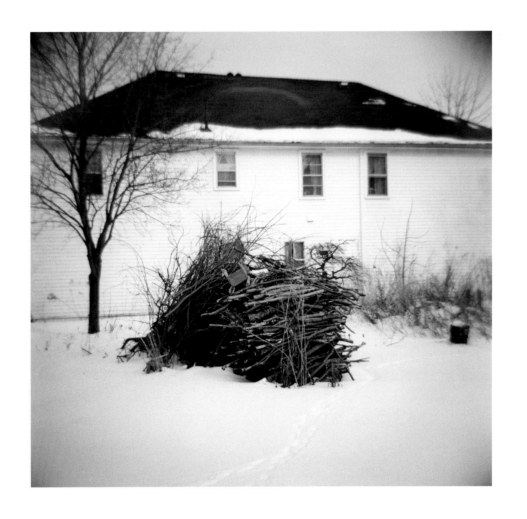

Branches, 2009

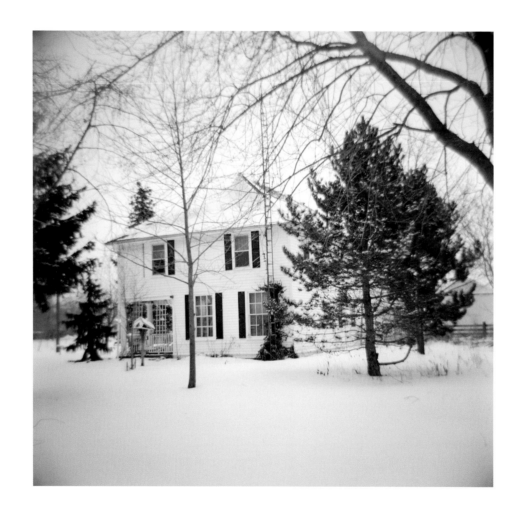

House, 2009

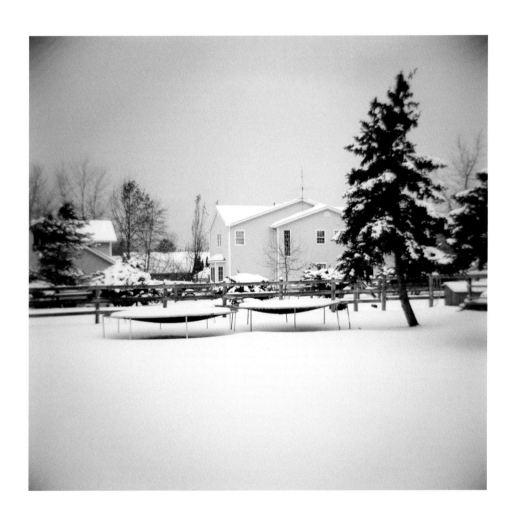

Trampolines, 2009

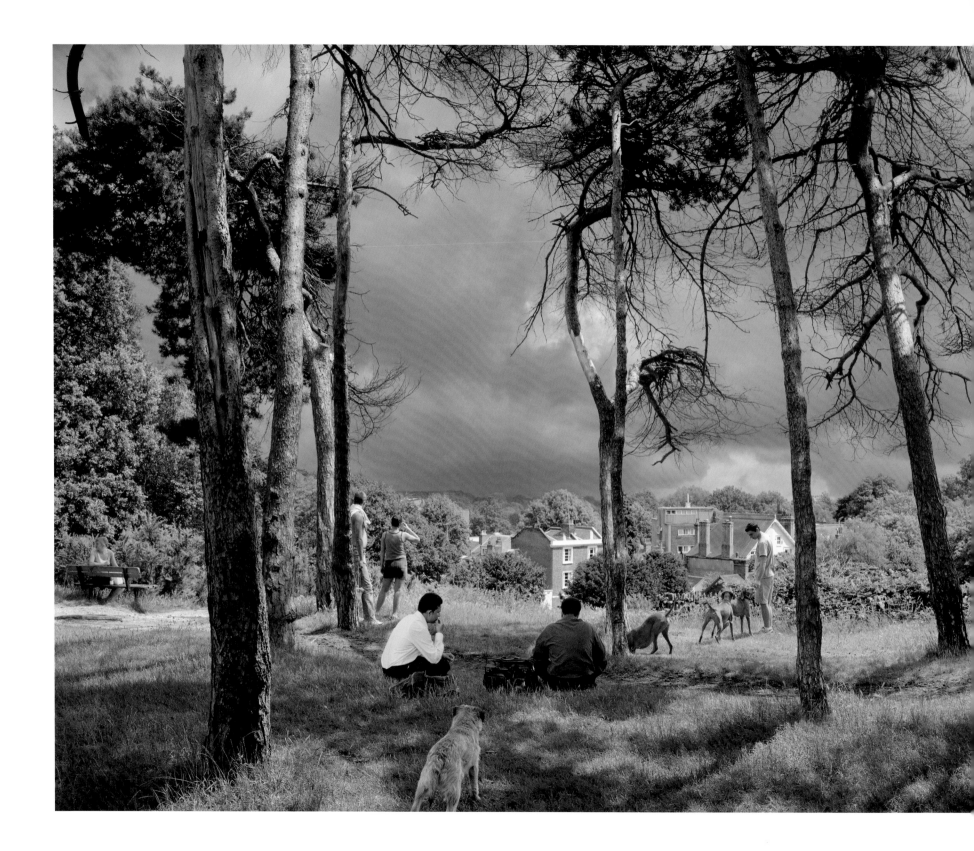

THE SKY IN SYMPATHY: SCOTT McFARLAND'S HAMPSTEAD SERIES

Martin Barnes

The closest Londoners get to Arcadia within the city is Hampstead Heath, which spreads out along a hill eight kilometres to the north of the metropolis. Standing windswept here on one of the highest points in the capital, in the midst of the 320-hectare expanse, you can hold the illusion of being in open country—even if the surrounding buildings, the city in a distant haze and the nearby buzz of millions of busy lives pull at its fringes. Scott McFarland has used this terrain to great effect in one of his most alluring, enigmatic and multi-layered series to date: people walk their dogs or relax in contemplation of the view; indigenous plants share the land with newer arrivals; as in times past, women drape washing to dry on the bushes; a walled herb garden seems silently enchanted; a giant blasted tree lies fallen, its branches like forks of lightning. And above all there is the sky.

The area has long had a distinguished artistic and poetic disposition: the poet Leigh Hunt made his home in Hampstead from 1815 to 1820, as did his friend John Keats around the same time. The two often walked on the Heath for inspiration. To these Romantics (and I expect for McFarland as well) the topography demonstrated how an ancient landscape could coexist within the modern world, a trope for how man and nature can be as closely allied as the Heath and the surrounding city. The poets were soon followed by painters, notably John Constable (1776—1837), whose fame makes comparison between him and any subsequent artist depicting Hampstead inevitable (fig. 1). In 1821 and 1822, Constable rented a house in Hampstead to facilitate a campaign of what he described as "skying": painting cloud studies outdoors (fig. 2). These studies were made with poetic nuance, an understanding of natural phenomena and scientific rigour; his notes on the back often indicate weather conditions, the date and the time of day they were painted—much like a record of aperture, light reading or photographic shutter speed. With its exposure to the elements, the Heath acted as Constable's open-air observatory. Echoes of this history are felt in McFarland's *Hampstead Reservoir Observatory* (2006), where a telescope

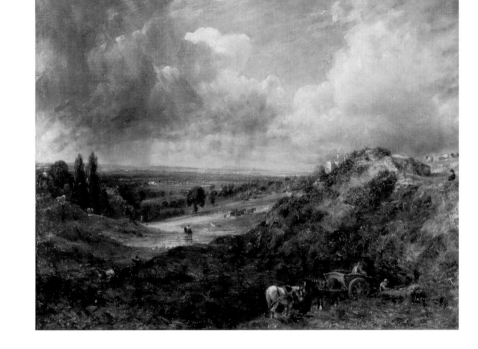

1
John Constable
Hampstead Heath; Branch Hill Pond, 1828
oil on canvas
60 x 78 cm
Collection of Victoria and Albert Museum, London

2
John Constable
Study of Clouds, 1822
oil on paper
29.8 x 48.3 cm
Collection of Victoria and Albert Museum, gift of
Isabel Constable Inscribed on the back in ink by the
artist: "Sepr. 5 1822. Looking S.E. noon. Wind very
brisk. & effect bright and fresh. Clouds. Moving very
fast. With occasional very bright openings to the blue."

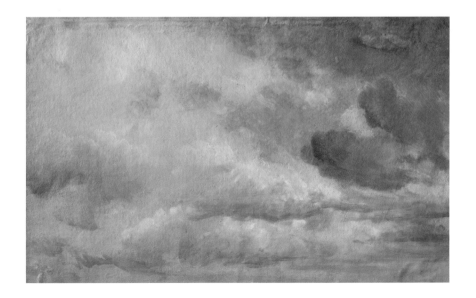

Gorse and Broom, West Heath, Hampstead (edition 3/5), 2006

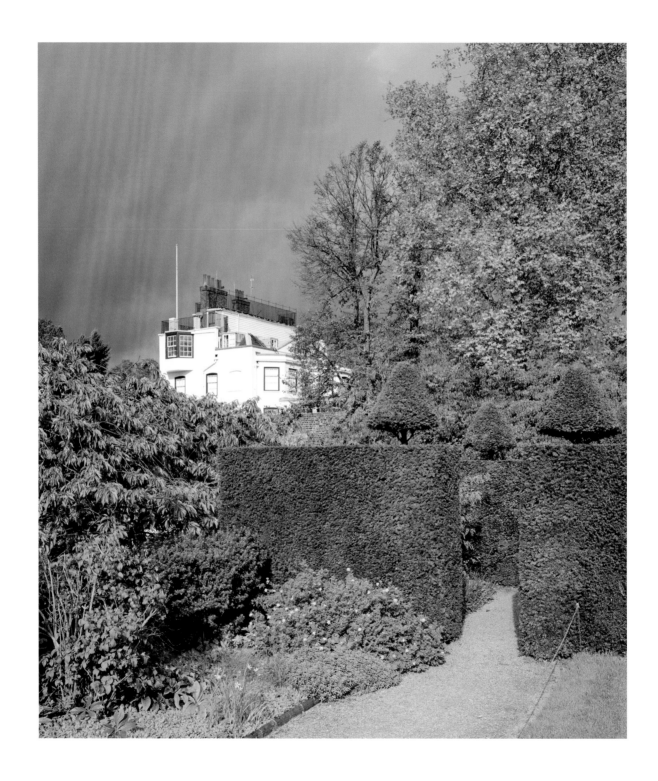

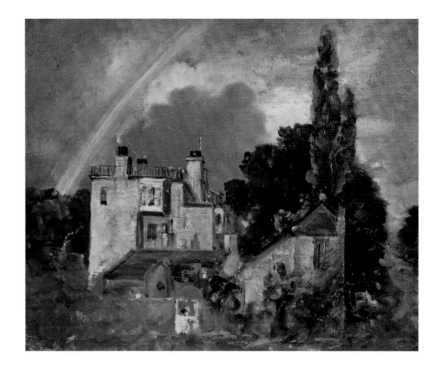

3
John Constable
The Grove, or Admiral's House, Hampstead, 1821–1822
oil on paper laid on canvas
24.5 x 29.2 cm
Collection of Victoria and Albert Museum, gift of Isabel Constable

The Admiral's House, as Seen from the Upper Garden at Fenton House (edition 2/5), 2006

peeps skyward out of its dome and figures attend to measuring devices at a weather station. The explicit message here is about meteorological observation, overlapping with ideas about optical observation (the telescope viewing the sky, in turn viewed and recorded through McFarland's lens).

McFarland is well tuned to the light conditions in the different locations around the world where he works. In his Hampstead series, perhaps more so than in any other, his acute awareness of the sky, like Constable's, becomes such a part of his compositions that the landscapes, no matter how distinct, seem beholden to the sky's prevailing mood. Constable emphasized the sky's importance, describing it in musical terms as the "key note" and in terms of proportion and emotion as the "standard of scale and organ of sentiment." The effect of differing skies on the same scenes, with resulting variations in emotional timbre from bright to brooding, can be seen by comparing any two of the four versions of his *Salisbury Cathedral from the Bishop's Grounds* (figs. 4, 5). Likewise, McFarland revisits Constable's uncannily photographic methods of superimposition, and even some of the very same Hampstead sites, as in *The Admiral's House* (2006) (see McFarland's photograph, left, and fig. 3). Numerous images

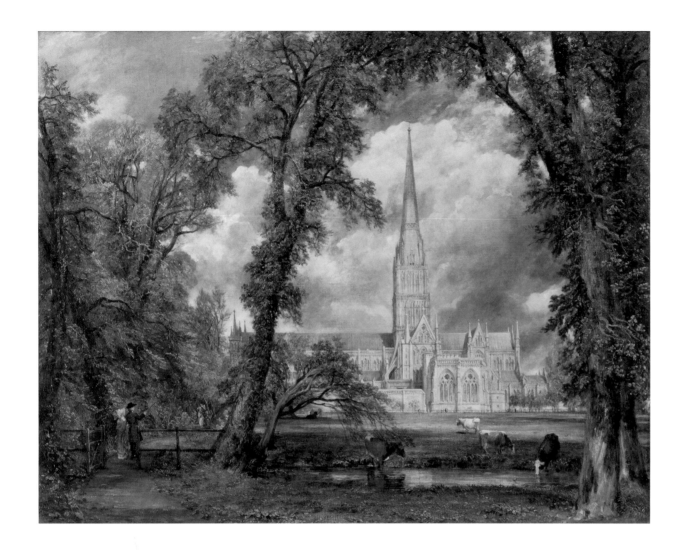

4
John Constable
Salisbury Cathedral from the Bishop's Grounds, 1823
oil on canvas
63 x 76 cm
Collection of Victoria and Albert Museum,
gift of John Sheepshanks

in the series are different versions of the same photographs, in which foregrounds and figures remain unaltered and only the sky changes. In this way, the artist draws our attention to the process of image manipulation. However, whereas Constable's concern for accuracy led him to change the light and shadow on his landscapes in sympathy with differing skies, McFarland chooses not to do so. A sky from one day or season imposed on the hybrid landscape of another means the appearance of naturalism in the photographs may be deliberately intended not to withstand more rigorous examination. This is perhaps the embodiment of a peculiarly contemporary sense of dislocation beneath the well-ordered surface.

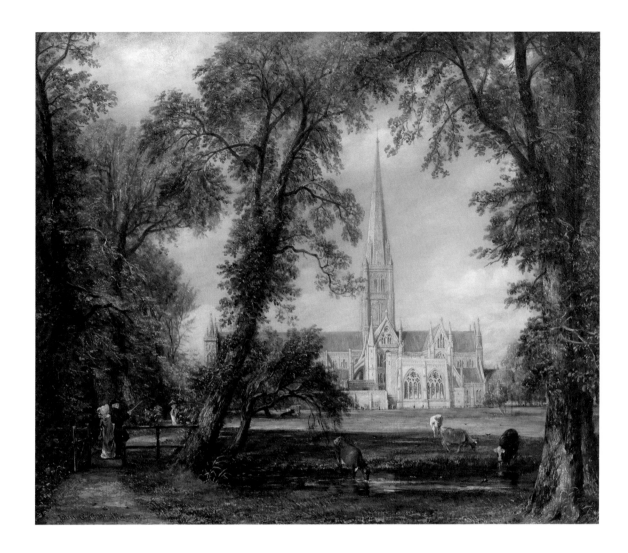

5
John Constable
Salisbury Cathedral from the Bishop's Grounds, 1823
oil on canvas
63 x 76 cm
Collection of the Huntington Library, Art Collections,
and Botanical Gardens, San Marino, California

Constable's open-air studies were painted with an unusual combination of dashing spontaneity and unerring yet artful accuracy—qualities that come naturally to the art of photography. Recent commentators have proposed that the invention of photography followed so hard on the heels of this difficult yet desirous combination that—rather than any fortuitous melding of chemistry and optics—it was a latent urge for instantaneous precision that gave birth to the new art. McFarland views Constable's work as an expression of a nascent photographic moment, when particular subject matter and its aesthetic treatment laid a foundation for early photography. For him, returning to Hampstead is like investigating the origin of an idea that has since

View of Rooke House, Looking towards Highgate (edition 2/5), 2007

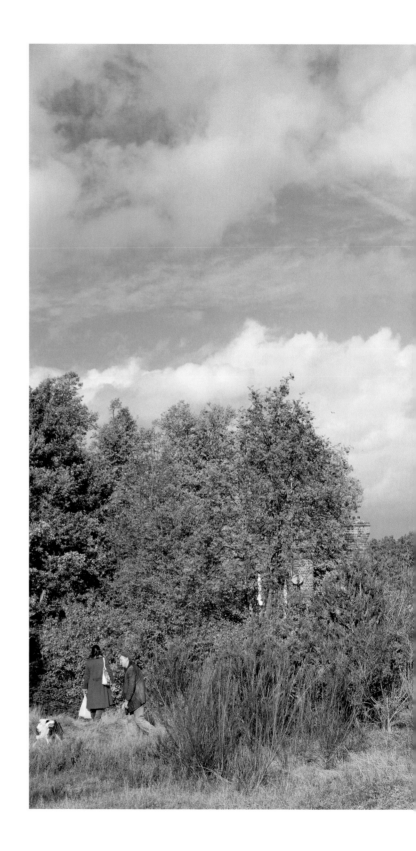

View of Rooke House, Looking towards Highgate (edition 4/5), 2007

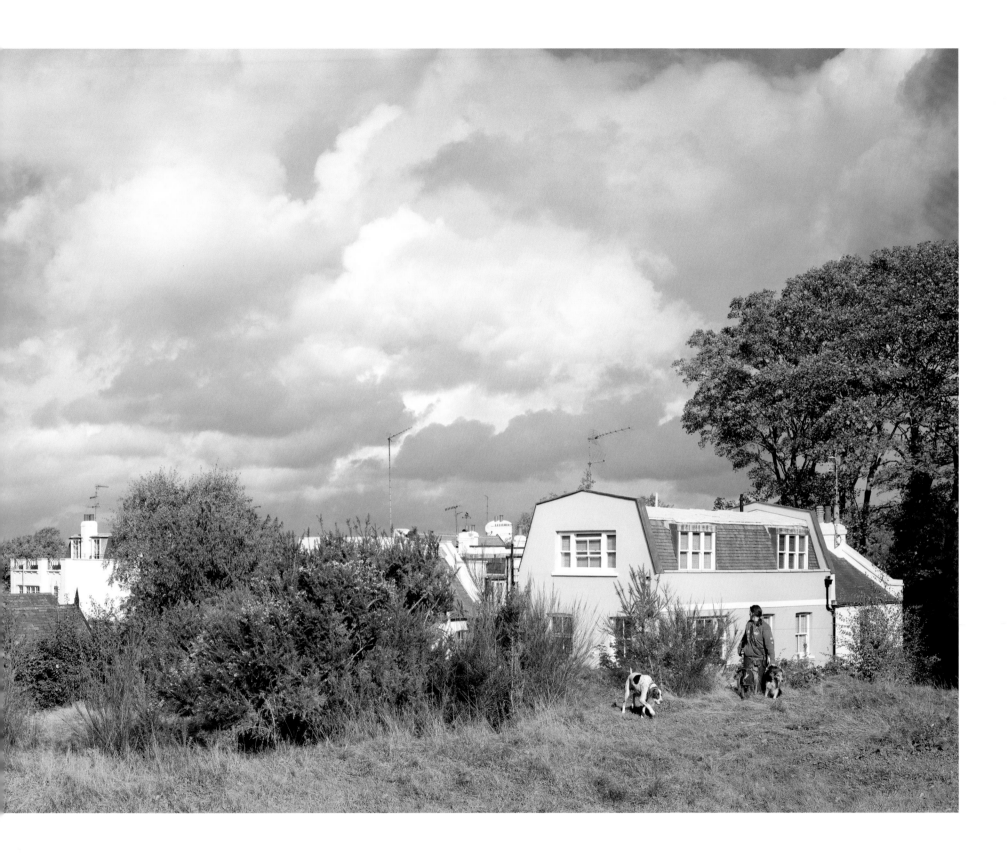

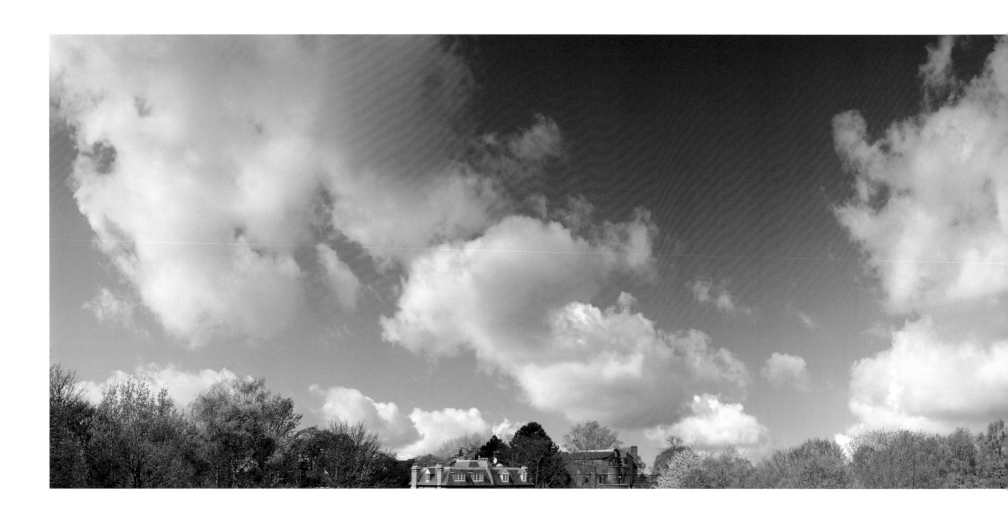

Judges Walk, Looking towards Jack Straw Castle (edition 2/5), 2009

permeated contemporary picture-making. He recaptures some of the excitement of these origins, when the sheer marvel of detail captured by the lens and fixed as a print was worthy of contemplation in its own right. Connoisseurs of photography in the nineteenth century enjoyed examining prints with a magnifying lens. McFarland's painstaking methods of digital production reward similar lingering scrutiny.

Theories of art in the late eighteenth and early nineteenth century often grappled with the relative merits of poetry and painting. Through its narrative structure, poetry could lead the mind until attention was totally engaged.

With painting, the same result had to be achieved in a single blow. Champions of painting (and, we might add, photography) cited its superior descriptive power and ability to isolate the pregnant moment in a narrative sequence, summing up the past, present and implications for the future. Vital to this scheme, with their fleeting moods like human expressions, skies embodied the potential for change, hinting to and colluding with the viewer's imagination that the narrative process was set in motion. And yet the artist's picture remains tantalizingly poised. McFarland's photographs are ripe with such pregnant moments, fixing the ephemeral with beguiling natural artifice.

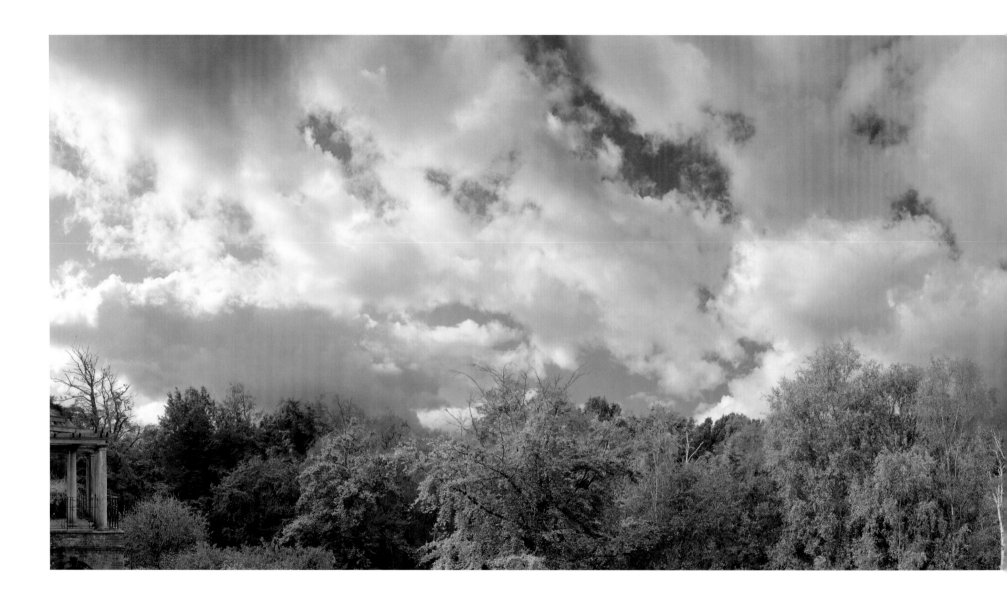

Hill Garden Pergola, Looking towards West Heath (edition 2/5), 2009

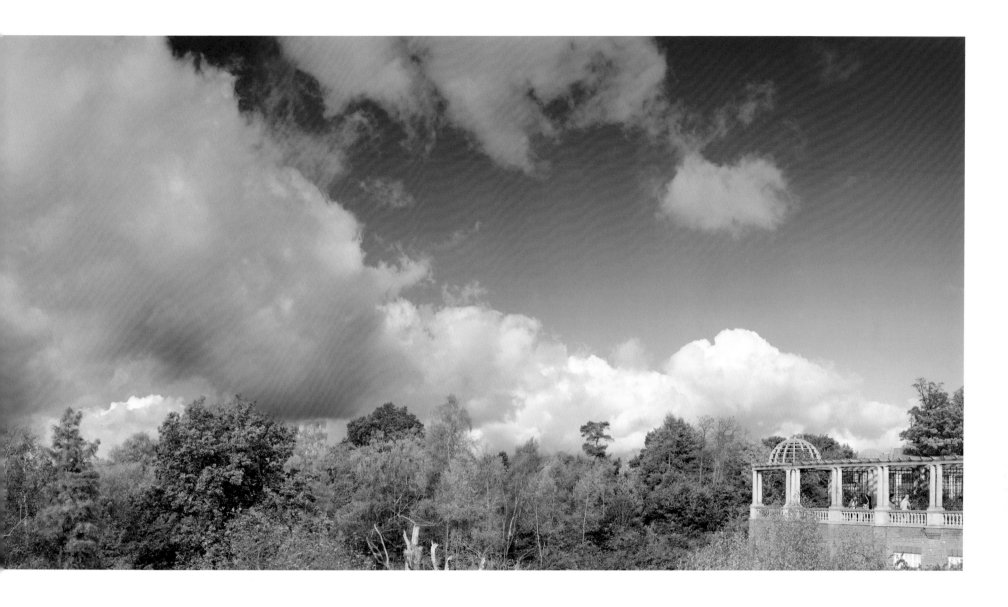

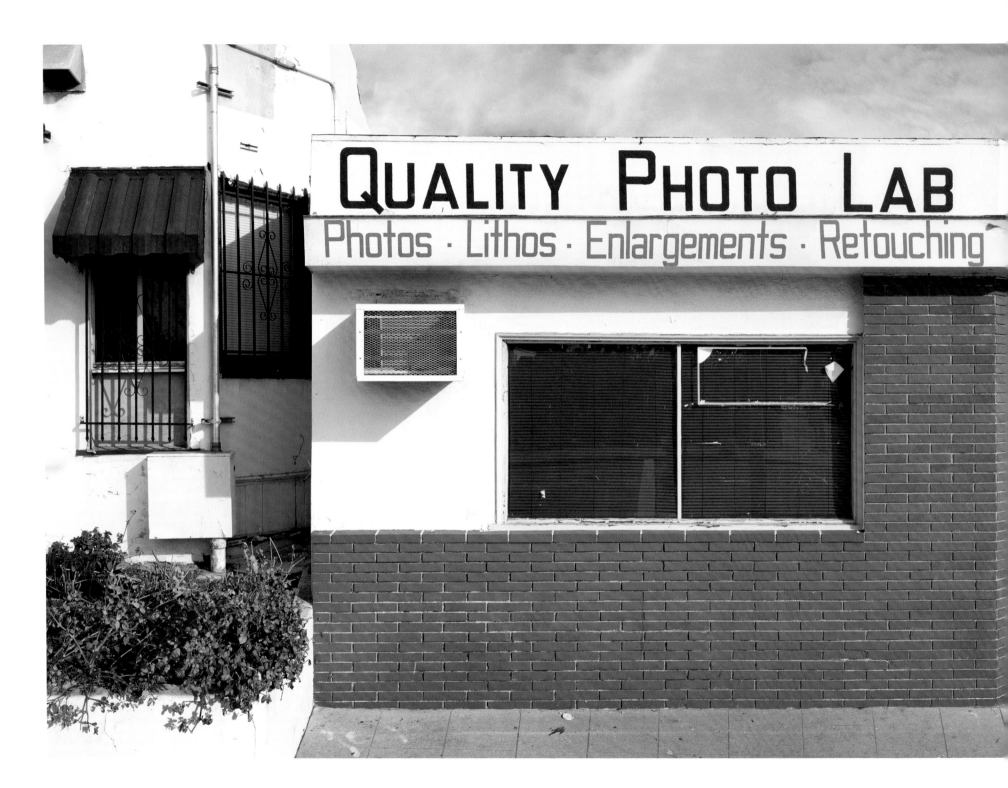

Quality Photo Lab, 1300 Cahuenga Blvd., Los Angeles, 2008

THE RESPONSIBILITY OF PHOTOGRAPHY

Shep Steiner

We harbour so many worries about the digitalization of photography, but none of these are shared by photography itself. Having gained distance from the processes of the darkroom by virtue of digital technologies, photography finds fulfillment, crowns its identity, treats what we take to be uncertainties as existential facts. All of which raises the question, where does one draw the line between our investment in the medium—and by extension its projected responsibility—and how photography sees the matter? What is the responsibility of photography?

Odd as this question may be, presuming as it does an active and conscientious posture on the part of an inhuman medium, it is a fair one given the nature of photography and the nature of the changes it has recently undergone. Not only does it point to how contemporary imaging technologies answer or respond to photography's original set of commitments, but it conjures up the processes by which the traditional medium comes into being by reproducing in the form of its own reply the law constitutive of the medium itself. Simply put, inquiring into photography's responsibility reveals the origins of picture-taking to be double, and in so doing opens up rhetorical distinctions within photography as a whole, which enables the singling out of exemplary practices that leave other supposedly ethical ones behind.

Take the case of traditional darkroom photography. When such photography is held to bear any responsibility at all (and it constantly is), the question typically provokes a spectrum of Enlightenment-oriented, journalistic and juridical-type responses that would have it bear witness, record or document history, provide factual evidence in a court of law or scientifically verify and record natural processes and phenomena. The moral imperative is clear: through various means of forging bonds with the past, the other, the natural world, historical events or members of a like-minded community, photography's responsibility is to reference, thereby upholding the concept of truth (and by extension, the notion of rights) in democracy itself. No consideration of photography's responsibility will be able to sidestep the truth content of the medium.

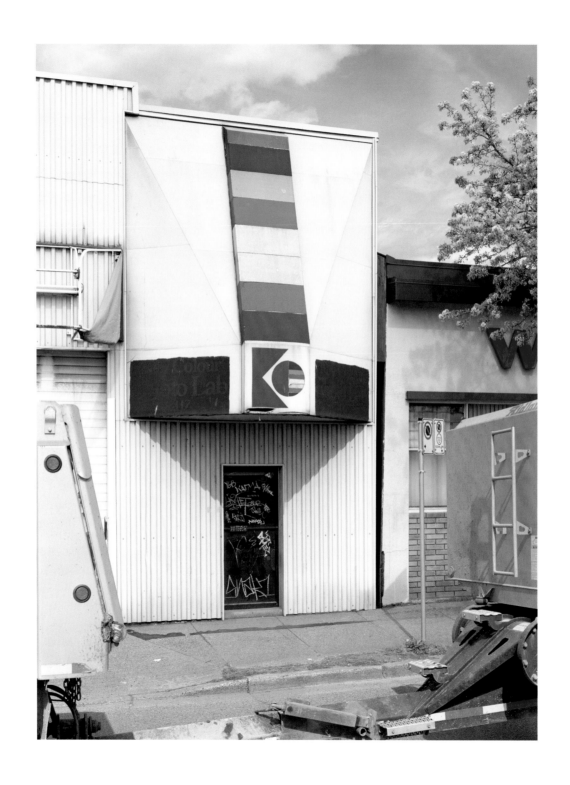

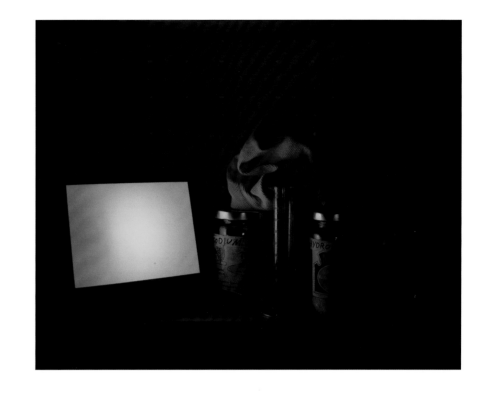

Safelight with Darkroom Chemicals, 2003–2006

Former Photography Lab, Key Colour, 117 2nd Ave East, Vancouver, 2009

As the modern medium par excellence, the medium in which responsiveness finally becomes generative—unlike in painting, for instance—it may be said that response-ability is built into the very nature of photography. Mimesis, that trope and motor of engagement so crucial to painting, is picked up by photography and elevated to the status of a science. Beginning with the relation that is exposure, photography has—*photography is*—the unique capacity to make correspondence into a thing. The emulsive surface of the traditional medium is an infinitely perceptive and sensitive one: a surface that has always striven to picture as truthful an image of the world as its resources allow. No doubt its model of transparency and anamnesis provided Freud a paradigm for the psychoanalytic project; early on, as the exteriorization of an internal process, it must have also provided a sounding board to articulate the logic of his *Project for a Scientific Psychology* (1895): "to furnish . . . a psychology which shall be a natural science: its aim . . . to represent psychical processes as quantitatively determined states of specifiable material particles and so to make them plain and void of contradictions." Although it would not be until the advances made possible by the binary code that imaging technologies would

Sugar Shack, Caledon, Ontario, 2009

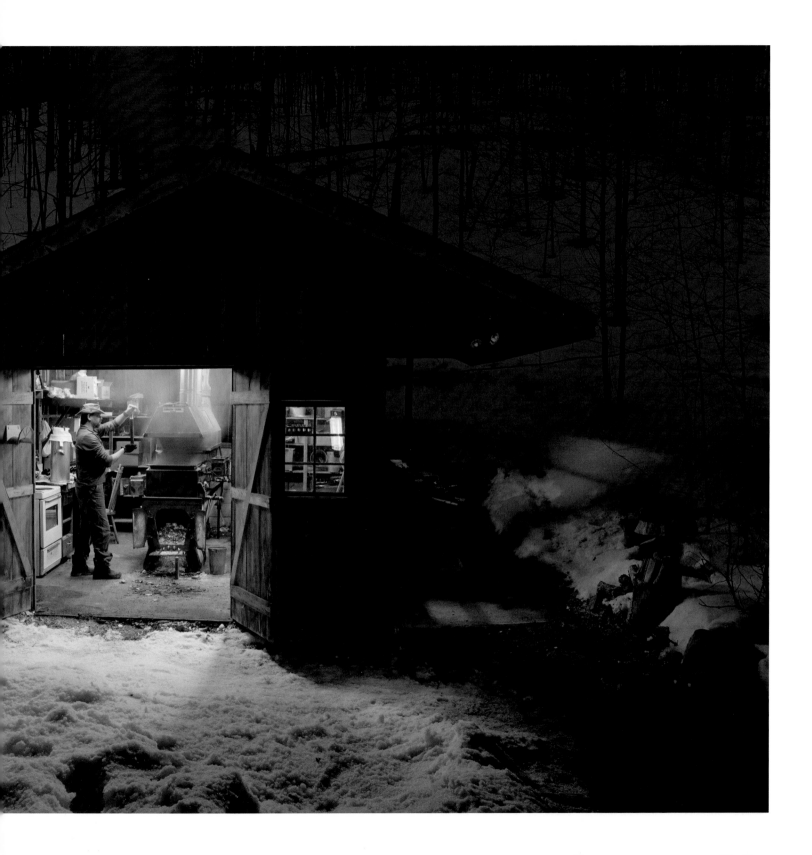

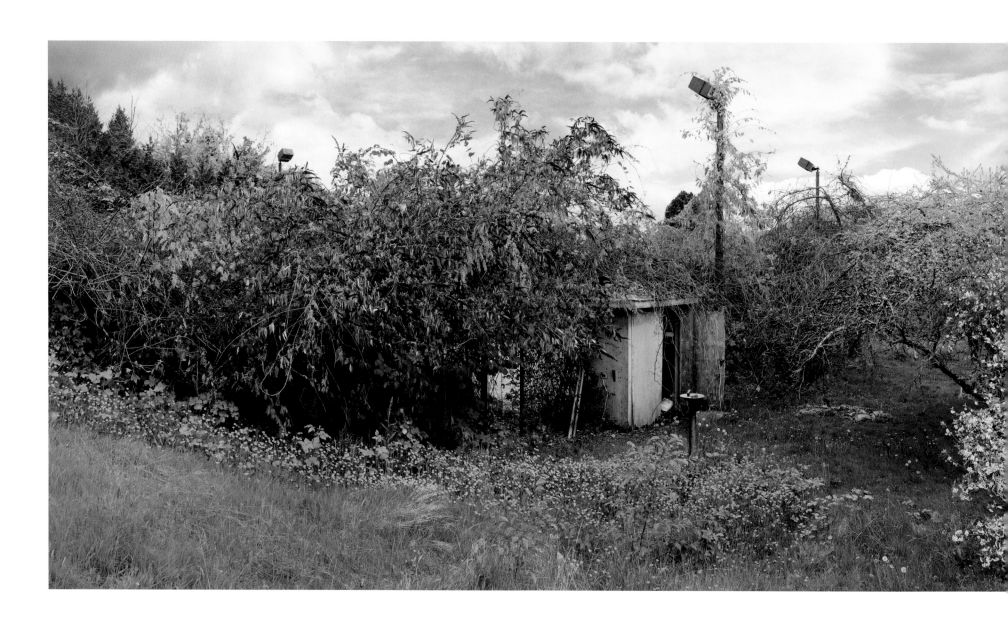

Orchard View with the Effects of the Seasons (Variation #2), 2003–2006

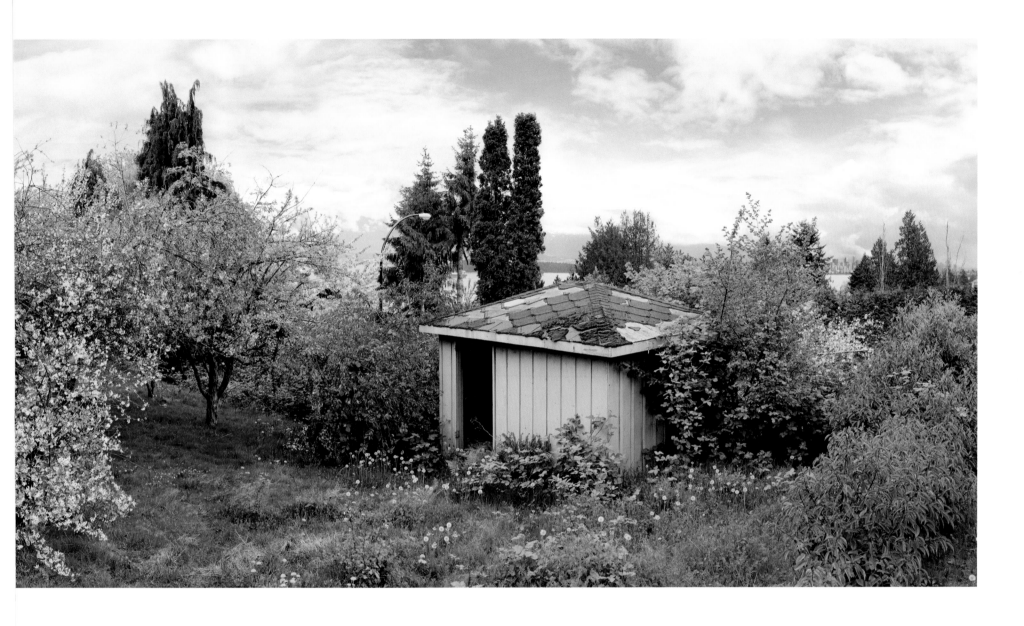

has suffered at the hands of an archive of zeroes and ones that is, in the final accounting, a materiality no longer strictly bound to matter as such and inasmuch alterable, but the dialectical overcoming of an earlier form of immediacy by a new stage of technical development animates a higher form of knowing, one that exists alongside (and before) both the intelligence of the original medium and its surrogate."

How to theorize this development without collapsing the distance gained, or fetishizing either one of the optics put into play, is the single largest problem now facing generalized, theoretical writing on photography (as a medium with a history). For how to document the intelligence taking shape when its status as "future anterior" is disconnected from the phenomenological circuitry of the here and now? As a reflection on a moment just past, from a present that knows itself to be in error, the event that photography now asks us to mark would not only seem to lie beyond any human intervention or interface, but in distinction to global capital's accelerated logic—read: contingency, calculated risk or the investment of speculative capital in probable futures and always other markets or underdeveloped modernities. The place photography is claiming for itself by virtue of the distance it has gained from the darkroom represents a critical moment in the life of the medium, a moment of self-consciousness where its future sentience is determined.

A conceptual reduction is in order, for we make no headway into the nether-world of photography without recognizing the evolution of photography from the darkroom to the well-lit workstation as its own deconstruction and as the narrativization of Plato's Allegory of the Cave. The history of photography in three moves, then: (1) The development of a mimetic figure of immediacy grounded in extrinsic reference; (2) A stopgap measure to stabilize a second figure of knowing (or content) that unfolds from questions intrinsic to the first; (3) Fixing this predicament, for taking the latter figure of mimesis as

Women Drying Laundry on the Gorse, Vale of Health, Hampstead Heath (edition 4/5), 2007

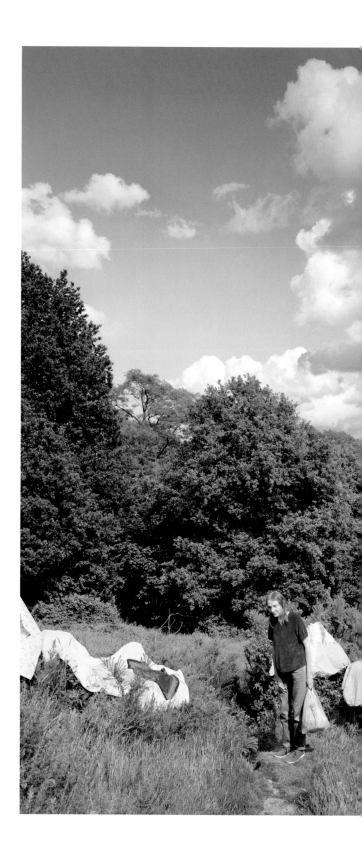

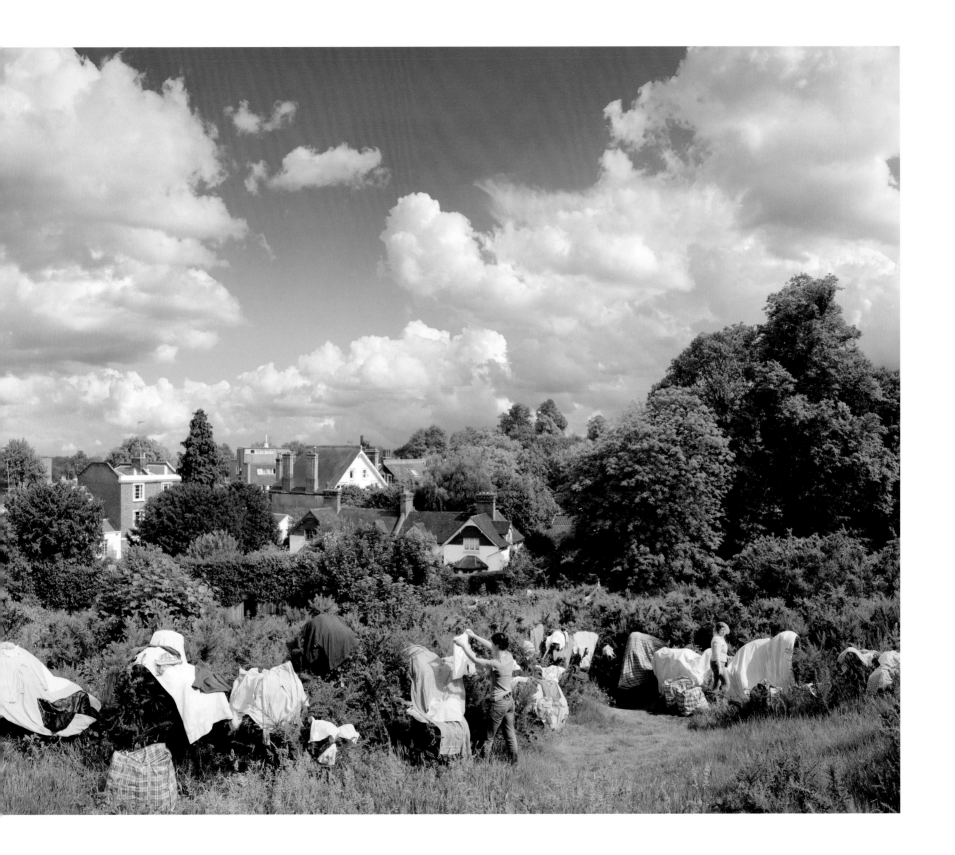

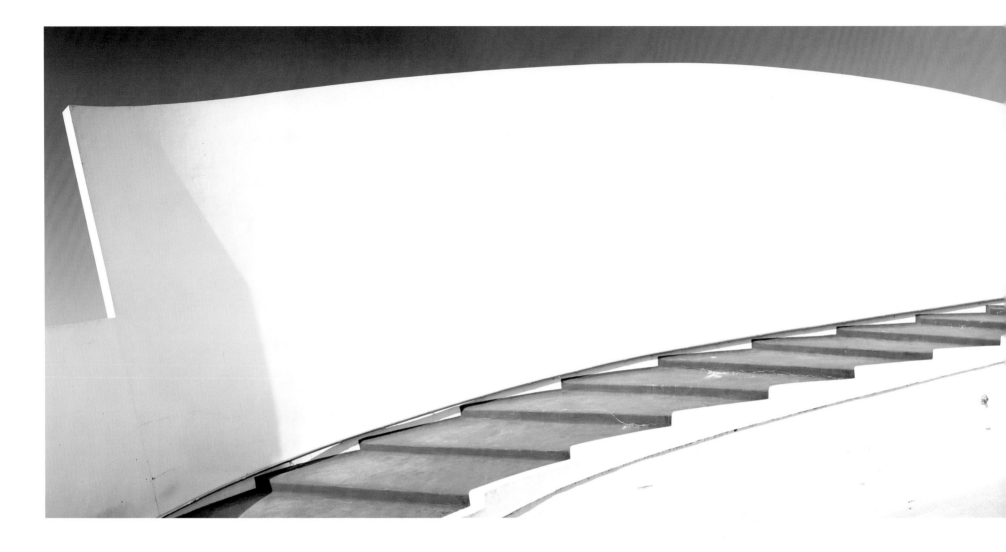

the final truth of photography is not a solution, and neither is simply inverting or fleshing out the truth content of said figure to arrive at a further negation. The unstable substitution of positive for negative and so on is merely an instance of mechanical reflex and does nothing more than put the dialectical resources of the system into high gear—something prohibitive of a speleological enterprise in the fullest sense. No. If we are to circumvent the problem of hypostatizing the negative that ritually occurs between steps one and two (and thereafter), we need to throw light on a narrow passage subtending the system of symmetrical oppositions. Following Lacan's remapping of this terrain first plumbed by Freud, we can mark the former as merely playing

Ping-Pong with the imaginary; we can suggest that if the symbolic is to be grasped in its expanded sense, then attending to the play of echoes implicit to the game itself is necessary; finally, we can say that if a passage leading beyond the symbolic logic of the machine is to be found, then a hole must be punched through the computational system of switches and relays that form any one circuit.

Unstable, disorienting and subject to continual subsidence, this aporetic structure between two very different nomological regimes (constantly pursued as autonomous generators of truth in their own right) is an opening in the

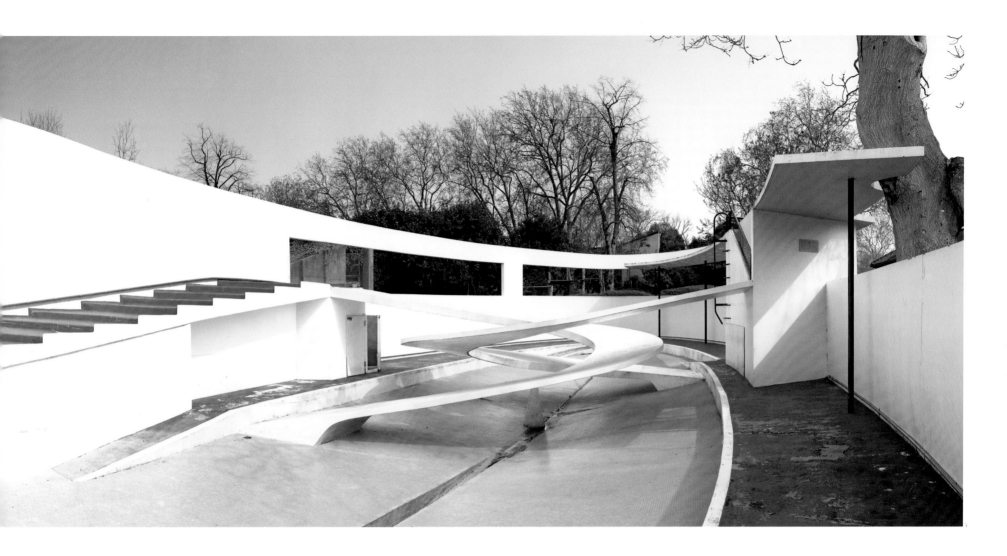

ground that metaphysics would rather deny. Detailed round with coralline structures, crystalline growths, secretions and thin vermiculations, the aesthetic fissure in question is little more than a drip hole or drainage for mineral-soaked pools. Percolating processes draw one in. Only a deep expulsion of air from lungs gets one through the pinch. A classic "roof sniff," one makes one's way through the constriction backward, with nose to ceiling, head submerged in the flux and flow. Only a parable of what the Platonic narrative of the cave overlooked can speak to this secret way forward. Only those adventurous few who have already drowned in the subterranean current that flows there can know the peculiar grit and odour of linguistic death that awaits. And yet this opening to the future lies ready, a possibility to be discovered at bottom, little more than a cleft in the ground that Nietzsche described as "not bridged over."

Emptied Penguin Pool, London Zoo, May 2008, Architect: Berthold Lubetkin, 1934, 2009

105

LIST OF ILLUSTRATED WORKS
BY SCOTT McFARLAND

Where no collection is noted, images are courtesy of the artist. Dimensions are height x width.

FROM THE SERIES *CABIN*

Cabin with Motion Light, 2001
chromogenic print
110 x 137 cm
Collection of the Vancouver Art Gallery
page 13

Embers, Late Evening, 2002
chromogenic print
152 x 122 cm
Collection of the Morris and Helen Belkin Art Gallery, purchased with the financial support of the Canada Council for the Arts Acquisition Assistance Program and the Morris and Helen Belkin Foundation, 2003
page 8

Lamplight, Objects of Glass and China, 2002
chromogenic print
120 x 147 cm
page 111

Torn Quilt with Effects of Sunlight, 2003
chromogenic print
112 x 148 cm
Collection of the Museum of Modern Art, New York, gift of Carol and David Appel
pages 16–17

FROM THE SERIES *BOATHOUSE*

Coiled Wire, 2002
chromogenic print
51 x 61 cm
Collection of the Vancouver Art Gallery, gift of Michael Audain and Yoshiko Karasawa
page 40

Rope, 2002
chromogenic print
61 x 51 cm
Collection of the Vancouver Art Gallery, gift of Michael Audain and Yoshiko Karasawa
page 43

Bench, 2003
chromogenic print
61 x 51 cm
Collection of the Vancouver Art Gallery, gift of Michael Audain and Yoshiko Karasawa
page 39

Boathouse with Moonlight, 2003
chromogenic print
180 x 231 cm
Collection of the Vancouver Art Gallery, gift of Michael Audain and Yoshiko Karasawa
page 37

Wrapped Wire, 2003
chromogenic print
61 x 51 cm
Collection of the Vancouver Art Gallery, gift of Michael Audain and Yoshiko Karasawa
page 42

Corner, 2004
chromogenic print
51 x 61 cm
Collection of the Vancouver Art Gallery, gift of Michael Audain and Yoshiko Karasawa
page 38

Winch, 2004
chromogenic print
51 x 61 cm
Collection of the Vancouver Art Gallery, gift of Michael Audain and Yoshiko Karasawa
page 44

Anchor, 2006
chromogenic print
51 x 61 cm
Collection of the Vancouver Art Gallery, gift of Michael Audain and Yoshiko Karasawa
page 45

Driftwood, 2006
chromogenic print
61 x 51 cm
Collection of the Vancouver Art Gallery, gift of Michael Audain and Yoshiko Karasawa
page 41

FROM THE SERIES *GARDENS*

Inspecting, Allan O'Connor Searches for *Botrytis cinerea*, 2003
chromogenic print
102 x 122 cm
page 14

Reshoeing, Farrier James Findel with Assistant on Southlands, 2003
chromogenic print
102 x 122 cm
page 10

Orchard View with the Effects of the Seasons (Variation #1), 2003–2006
chromogenic print
102 x 305 cm
Collection of George Hartman and Arlene Goldman
pages 18–19

Orchard View with the Effects of the Seasons (Variation #2), 2003–2006
chromogenic print
102 x 305 cm
Collection of Joe Shlesinger
pages 98–99

Fountain Study, Late Fall; *Cedrus atlantica,*
Acer palmatum, Populus nigra, 2004
chromogenic print
102 x 279 cm
Collection of the families of Steven Latner
and Michael Latner
pages 32–33

On the Terrace Garden, Joe and Rosalee Segal
with *Cosmos atrosanguineus,* 2004
chromogenic print
102 x 122 cm
page 6

Orchard on Dr. Young's Property, 3226 W. 51st,
Vancouver, 2005
ink jet print
102 x 305 cm
William J. Hokin Collection
pages 62–63

Stables on Dr. Young's Property, 3226 W. 51st,
Vancouver, 2005
chromogenic print
102 x 305 cm
William J. Hokin Collection
pages 64–65

FROM THE SERIES *EMPIRE*

Huntington Botanical Gardens, San Marino,
California. Desert Garden Nursery with Succulent
Collections Donated by Virginia Martin and
Seymour Lyndon, Spring 2005, 2005
ink jet print
102 x 409 cm
Collection of William and Ruth True, Seattle
pages 20–21

Huntington Botanical Gardens, San Marino,
California. Desert Garden Nursery with Succulent
Collections Donated by Virginia Martin and
Seymour Lyndon, Spring 2005, 2005
ink jet print
76 x 263 cm
pages 50–51

Agave americana variegata, 2006
ink jet print
62 x 70 cm
Collection of Enrico Pallota and Brigitte Laforest
page 57

Aloe principis, 2006
ink jet print
64 x 71 cm
page 55

Echinocactus grusonii, 2006
ink jet print
62 x 70 cm
Private collection, Toronto
page 56

Euphorbia ingens, 2006
ink jet print
71 x 64 cm
Private collection, Toronto
page 52

Opuntia microdasys, 2006
ink jet print
64 x 71 cm
page 54

Opuntia pittieri, 2006
ink jet print
70 x 62 cm
Collection of David Allison and Chris Nicholson,
Vancouver
page 59

Washingtonia filifera, 2006
ink jet print
64 x 71 cm
Courtesy of the artist and Monte Clark Gallery,
Vancouver
page 58

Yucca brevifolia, 2006
ink jet print
62 x 70 cm
page 53

FROM THE SERIES *HAMPSTEAD*

The Admiral's House, as Seen from the Upper
Garden at Fenton House (edition 2/5), 2006
ink jet print
46 x 52 cm
Collection of Paul Sinclaire and Eric Berthold
page 80

Gorse and Broom, West Heath, Hampstead
(edition 3/5), 2006
ink jet print
51 x 58 cm
Courtesy of the artist and Regen Projects,
Los Angeles
page 78

Hampstead Reservoir Observatory at Lower
Terrace, near Whitestone Pond (edition 4/5), 2006
ink jet print
77.5 x 117 cm
Collection of Monte Clark
pages 22–23

Hill Garden Pergola at Inverforth House
(edition 4/5), 2007
ink jet print
66 x 81 cm
page 34

View of Rooke House, Looking towards
Highgate (edition 2/5), 2007
ink jet print
76 x 91 cm
pages 84–85

View of Rooke House, Looking towards
Highgate (edition 4/5), 2007
ink jet print
76 x 91 cm
pages 86–87

View of Vale of Health, Looking towards
Hampstead (edition 3/5), 2007
ink jet print
69 x 108 cm
Courtesy of the artist and Regen Projects,
Los Angeles
pages 76–77

Women Drying Laundry on the Gorse, Vale of
Health, Hampstead Heath (edition 4/5), 2007
ink jet print
74 x 114 cm
Collection of George Hartman and Arlene Goldman
pages 102–3

Fallen Oak Tree (edition 2/5), 2008
ink jet print
69 x 61 cm
Courtesy of Byron Aceman, Vancouver
page 100

Gorse and Sky (edition 1/5), 2008
ink jet print
51 x 60 cm
Private collection, Toronto
page 24

Trees and Sky, West Heath (edition 2/5), 2008
ink jet print
56 x 69 cm
Courtesy of the artist and Clark & Faria, Toronto
page 108

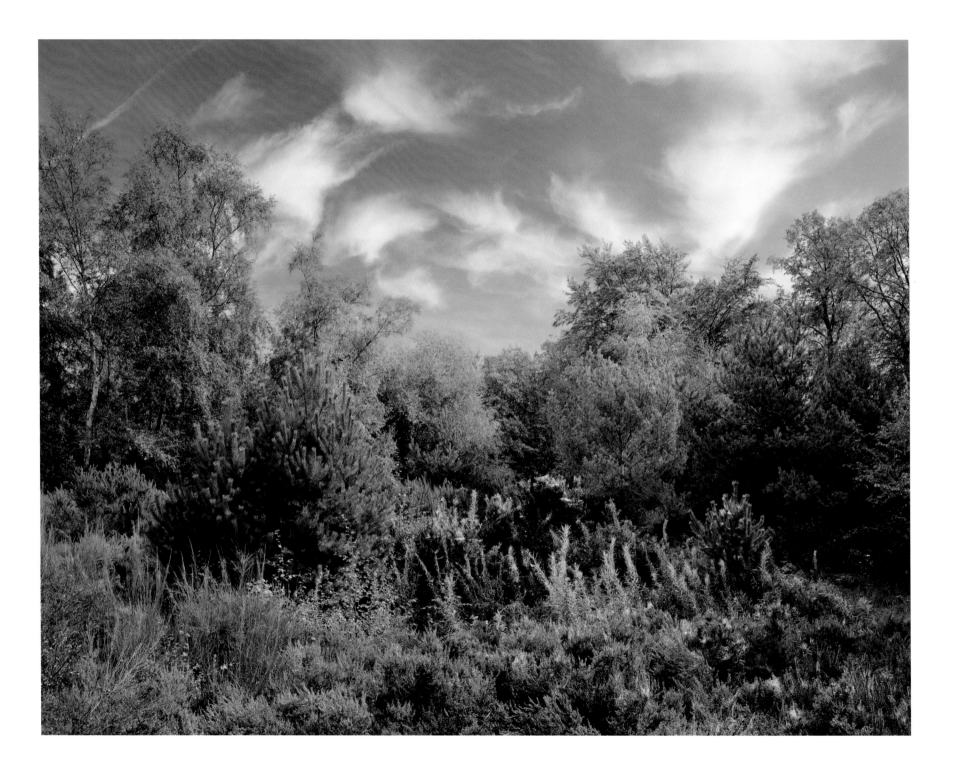

Hill Garden Pergola, Looking towards West Heath
(edition 1/5), 2009
ink jet print
55.9 x 175 cm
pages 2–4

Hill Garden Pergola, Looking towards West Heath
(edition 2/5), 2009
ink jet print
55.9 x 175 cm
pages 90–91

Judges Walk, Looking towards Jack Straw Castle
(edition 2/5), 2009
ink jet print
50 x 175 cm
pages 88–89

Judges Walk, Looking towards Jack Straw Castle
(edition 3/5), 2009
ink jet print
50 x 175 cm
Courtesy of the artist and Regen Projects,
Los Angeles
pages 116–17, 118–19 (details)

FROM THE SERIES *NIAGARA*

Branches, 2009
ink jet print
51 x 52 cm
Courtesy of the artist and Regen Projects,
Los Angeles
page 73

Feeder, 2009
ink jet print
51 x 52 cm
Courtesy of the artist and Regen Projects, Los Angeles
page 68

A Horse-Drawn Hearse, Queens Royal Tours,
174 Anne, Niagara-on-the-Lake, Ontario, 2009
ink jet print
152 x 315 cm
Courtesy of the artist and Clark & Faria, Toronto
pages 66–67

House, 2009
ink jet print
52 x 52 cm
Courtesy of the artist and Regen Projects,
Los Angeles
page 74

Marquee, 2009
ink jet print
51 x 52 cm
Courtesy of the artist and Regen Projects,
Los Angeles
page 69

Model T, 2009
ink jet print
51 x 52 cm
Courtesy of the artist and Regen Projects,
Los Angeles
page 71

Snow Man, 2009
ink jet print
51 x 52 cm
Courtesy of the artist and Regen Projects,
Los Angeles
page 72

Tractor, 2009
ink jet print
51 x 52 cm
Courtesy of the artist and Regen Projects,
Los Angeles
page 70

Trampolines, 2009
ink jet print
51 x 52 cm
Courtesy of the artist and Regen Projects,
Los Angeles
page 75

INDIVIDUAL WORKS

Safelight with Darkroom Chemicals,
2003–2006
digital file
page 95, back cover

Ruinberg, near Schloss Sans Souci, Potsdam
(edition 2/5), 2006
ink jet print
62 x 51 cm
Private collection, Toronto
page 31

Display for Porcupines *(Hystrix africae
australis),* Zoologischer Garten, Berlin, 2006
ink jet print
102 x 333
Collection of Family von Brauckmann
pages 48–49

The Granite Bowl in the Berlin Lustgarten
(after Johann Erdmann Hummel), 2006
ink jet print
66 x 98 cm
pages 26–27

Emptied Penguin Pool, London Zoo, May 2008,
Architect: Berthold Lubetkin, 1934, 2008
ink jet print
109 x 400 cm
Courtesy of the artist and Monte Clark Gallery,
Vancouver, Clark & Faria, Toronto, and
Regen Projects, Los Angeles
pages 46–47

Former Photography Lab, Key Colour,
117 2nd Ave East, Vancouver, 2009
ink jet print
183 x 152 cm
page 94

Quality Photo Lab, 1300 Cahuenga Blvd.,
Los Angeles, 2008
ink jet print
147 x 274 cm
Collection of the Vancouver Art Gallery,
purchased with funds from the Aqueduct
Foundation
pages 92–93

Emptied Penguin Pool, London Zoo, May 2008,
Architect: Berthold Lubetkin, 1934, 2009
ink jet print
102 x 264 cm
Courtesy of the artist and Regen Projects, Los Angeles
pages 104–5

Sugar Shack, Caledon, Ontario, 2009
ink jet print
183 x 267 cm
Courtesy of the artist and Monte Clark Gallery,
Vancouver, Clark & Faria, Toronto, and Regen
Projects, Los Angeles
pages 96–97, front cover

At left: **Trees and Sky, West Heath** (edition 2/5), 2008

LENDERS TO THE EXHIBITION

BYRON ACEMAN

DAVID ALLISON AND CHRIS NICHOLSON

PAUL BAIN

FAMILY VON BRAUCKMANN

MONTE CLARK

DANIEL FARIA

SHAUN AND STACY FRANCIS

CAROL GRAY

MATT HAMMATT

GEORGE HARTMAN AND ARLENE GOLDMAN

WILLIAM J. HOKIN COLLECTION

LORI KOZUB AND ROBERT L. HODGKINSON

FAMILIES OF STEVEN LATNER AND MICHAEL LATNER

ENRICO PALLOTTA AND BRIGITTE LAFOREST

PRIVATE COLLECTION, TORONTO

PRIVATE COLLECTION, VANCOUVER

MICHAEL AND SUSAN RICH

STEVE F. ROTH

RBC ROYAL BANK

PAUL SINCLAIRE AND ERIC BERTHOLD

JOE SHLESINGER

WILLIAM AND RUTH TRUE

Lamplight, Objects of Glass and China, 2002

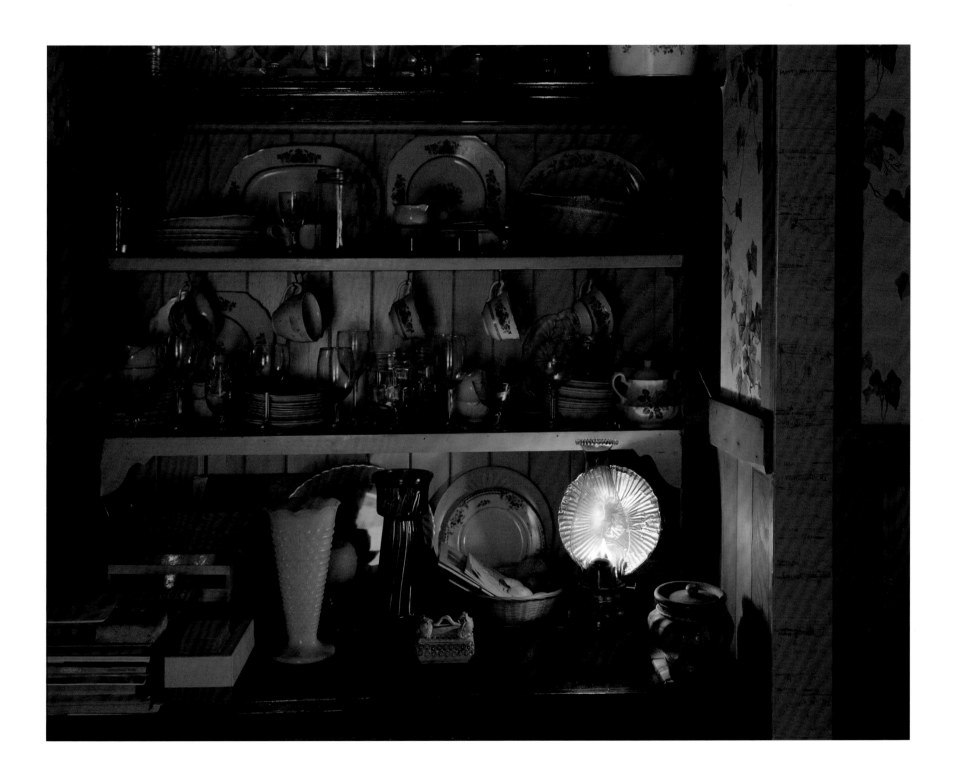

ARTIST'S BIOGRAPHY

Scott McFarland was born in Hamilton, Ontario, in 1975 and grew up in Fort McMurray and Calgary, Alberta. In 1997 he received a Bachelor of Fine Arts from the University of British Columbia, Vancouver. He currently lives and works in Toronto and Vancouver.

EXHIBITIONS

2009

Scott McFarland, Vancouver Art Gallery, Vancouver

Scott McFarland, Regen Projects, Los Angeles

Scott McFarland: A Cultivated View, Canadian Museum of Contemporary Photography and National Gallery of Canada, Ottawa

2008

Garden of Eden, Städtische Galerie, Bietigheim-Bissingen, Germany

New Works, Monte Clark Gallery, Toronto

2007

Acting the Part: Photography as Theatre, Vancouver Art Gallery

Crack the Sky, Biennale de Montréal

Garden of Eden, Kunsthalle Emden, Germany

Hybrid, Museum of Canadian Contemporary Art, Toronto

New Photography 2007, Museum of Modern Art, New York

Re-Envisioning Habitat, Oakville Galleries, Ontario

Sound and Vision, Centre Culturel Canadien, Paris

The Constructed Image: Photographic Culture, Museum of Contemporary Canadian Art, Toronto

Works on Paper, Monte Clark Gallery, Vancouver and Toronto; Regen Projects, Los Angeles; Union Gallery, London

2006

A History of Photography, Victoria and Albert Museum, London

Boys with Flowers, Western Bridge, Seattle

Click Doubleclick: The Documentary Factor, Haus der Kunst, Munich; touring to Palais des Beaux-Arts, Brussels

Faking Death, Jack Shainman Gallery, New York

Grid < > Matrix, Mildred Lane Kemper Art Museum, St. Louis

Landscape: Recent Acquisitions, Museum of Modern Art, New York

Sound and Vision, Montreal Museum of Fine Arts

2005

Analysing Trapping Inspecting, Union Gallery, London

Another Photography, Regen Projects, Los Angeles

Bucolica, Wallspace Gallery, New York

Contemporary Photographic Art in Canada: The Space of Making, Neuer Berliner Kunstverein, Berlin; touring to Kunstmuseum Heidenheim, Germany; Kunstsammlungen der Städtischen Museen Zwickau, Germany; Städtische Galerie Waldkraiburg, Germany

Intertidal: Vancouver Art and Artists, MuHKA, Antwerp

Real Pictures: Photographs from the Collection of Claudia Beck and Andrew Gruft, Vancouver Art Gallery

Variations on the Picturesque, Kitchener-Waterloo Art Gallery

2004

Everything's Gone Green: Photography and the Garden, National Museum of Photography, Film and Television, Bradford, England

Fabulation, VOX, Montreal

Gardens, Monte Clark Gallery, Vancouver and Toronto

Important Canadian Art, ZieherSmith Gallery, New York

2003

A Proposal for an Exhibition, Monte Clark Gallery, Toronto

Boathouse, Monte Clark Gallery, Toronto

Scott McFarland, Contemporary Art Gallery, Vancouver

Various Properties, Morris and Helen Belkin Art Gallery, Vancouver

2002

A Weird Science: Evan Lee and Scott McFarland, Monte Clark Gallery, Vancouver

elsewhere, WBD, Berlin

Imago 2002, Centro de Fotografia, Salamanca

Photonomena, Monte Clark Gallery, Toronto

Scott McFarland, Sharon Essor Gallery, London

2001

Scott McFarland: Cabin, Monte Clark Gallery, Vancouver

Roy Arden, Scott McFarland, Howard Ursuliak, Stephen Waddell, Jeff Wall, Monte Clark Gallery, Toronto

These Days, Vancouver Art Gallery

Vancouver Collects: Sun Pictures to Photoconceptualism; Photography from Local Collections, Vancouver Art Gallery

2000

Scott McFarland, Owen Kydd, Anodyne Gallery, Vancouver

Scott McFarland, Allan Switzer, Stephen Waddell, Monte Clark Gallery, Vancouver

1999

After Photography, Monte Clark Gallery, Vancouver

Scott McFarland: Cabin, Torstrasse 102, Berlin

1998

Edge City, Surrey Art Gallery, British Columbia

Scott McFarland, Or Gallery, Vancouver

PUBLICATIONS

2009

Kunard, Andrea. "Interview with the Artist." http://cmcp.gallery.ca/mcfarland/en/interview.htm.

Milroy, Sarah. "Nature cultivated and tame—and still so alien." *Globe and Mail,* May 2, 2009.

Scott McFarland: A Cultivated View. Ottawa: Canadian Museum of Contemporary Photography and National Gallery of Canada, 2009.

2007

Balaschak, Chris. "Scott McFarland." *Frieze,* October 2007, 293.

Eckmann, Sabine, and Lutz Koepnick. *Grid < > Matrix.* St. Louis: Mildred Lane Kemper Art Museum, 2007.

2006

Berardini, Andrew. "Critic's Picks: Interventions at Thomas Solomon Gallery @ Rental Gallery." *Artforum,* December 27, 2006. http://www.artforum.com. (online only)

Harrison, Adam. "Scott McFarland." *Canadian Art,* Spring 2006, 86–87.

Weski, Thomas, ed. *Click Doubleclick: The Documentary Factor.* Munich: Haus der Kunst, 2006.

2005

Arnold, Grant. "Real Pictures." In *Real Pictures: Photographs from the Collection of Claudia Beck and Andrew Gruft,* 113–14. Vancouver: Vancouver Art Gallery, 2005.

Harrison, Sarah. "Scott McFarland." *ArtReview,* April 2005, 105.

Henry, Karen and Karen Love. *Variations on the Picturesque.* Kitchener: Kitchener-Waterloo Art Gallery, 2005.

Henderson, Lee. "The Empire Grows Back." *Border Crossings,* Summer 2005, 50–56.

Intertidal. Antwerp: MuKHA, 2005.

Jean, Marie-Josée. "The Space of Making." *Zeitgenössische Fotokunst aus Kanada.* Berlin: Neuer Berliner Kunstverein, 2005. (unpaginated)

Langford, Martha. "Doubtful Realisms and Paradisi-acal Gains." In *Image & Imagination,* 119–22. Montreal: McGill-Queen's University Press, 2005.

McFarland, Scott. "Empire." In *Image and Inscription: An Anthology of Contemporary Canadian Photography,* edited by Robert Bean, 131. Toronto: YYZ Books, 2005.

Pagel, David. "Moments Captured—and Combined." *Los Angeles Times,* October 21, 2005.

Shirreff, Neil. "Garden Designs." *Source Photographic Review,* no. 42 (Spring 2005): 52–53.

2004

Driedger, Sharon Doyle. "Ten Artists Who Rock." *Maclean's,* January 12, 2004, 42.

Henderson, Lee. *Important Canadian Art.* New York: ZieherSmith Gallery, 2004.

McFarland, Scott. "A Photographer in the Garden." *Canadian Art,* Summer 2004, 58–63.

Milroy, Sarah. "Nothing Is Perfect in Shangri-la." *Globe and Mail,* November 19, 2004.

Rae, Ines. "More Plant Matters." *Source Photographic Review,* no. 39 (Summer 2004): 50–51.

Skerrett, Penny. "Everything's Gone Green: Photography and the Garden." *Archive,* no. 2, (2004): 23.

Thornton, Sarah. "Nocturnes." *Contemporary,* no. 62 (2004): 32–37.

2003

Buckrell Pos, Tania. "Cold Fusion." *Canadian Art,* Spring 2003, 93.

Dault, Gary Michael. "Photographs Have a Cape Fear Quality." *Globe and Mail,* September 20, 2003.

Goddard, Peter. "Photographic Shows Work in Remembrance of Things Past." *Toronto Star,* February 27, 2003.

Sengara, Lorissa. "A Proposal for an Exhibition." *Canadian Art,* Spring 2003, 106.

Shier, Reid, ed. *Scott McFarland: Cabin Photographs.* Vancouver: Contemporary Art Gallery, 2003.

Turner, Michael. "Wall and Void." *Modern Painters,* Summer 2003, 39–41.

2002

Beck, Claudia. *A Proposal for an Exhibition.* Vancouver: Monte Clark Gallery, 2002. (unpaginated)

Imago 2002. Salamanca: Centro de Fotografia, 2002.

2001

Brayshaw, Christopher. "Garden Optics." *CV Photo* no. 54 (2001): 7–13.

———. "Cabin, 2001." *C Magazine,* Winter 2001, 40.

Milroy, Sarah. "Onward and Upward." *Globe and Mail,* August 13, 2001.

Scott, Michael. "Art of Global Importance." *Vancouver Sun,* May 5, 2001.

2000

Arden, Roy. "After Photography." *Canadian Art,* December 2000, 48–56.

McFarland, Scott. "Artist's Project." *Adbusters,* no. 29 (Spring 2000). (unpaginated)

1999

Arden, Roy. *After Photography.* Vancouver: Monte Clark Gallery, 1999.

Gopnik, Blake. "Reticence in Photography Is Good, Interview with Jeff Wall." *Globe and Mail,* November 6, 1999.

McFarland, Scott. "Artist's Project." *National Post,* January 13, 1999.

Scott, Michael. "Late Light." *Canadian Art,* Fall 1999, 118–19.

1998

Brayshaw, Christopher. *Edge City.* Surrey: Surrey Art Gallery, 1998.

PUBLIC COLLECTIONS AND FOUNDATIONS

Albright-Knox Art Gallery, Buffalo

Art Gallery of Ontario, Toronto

Canadian Museum of Contemporary Photography, Ottawa

Centro de Arte de Salamanca, Spain

Glenbow Museum, Calgary

Justina M. Barnicke Gallery, Hart House, University of Toronto

K21 Kunstsammlung Nordrhein-Westfalen, Düsseldorf

Mendel Art Gallery, Saskatoon

Montreal Museum of Fine Arts

Morris and Helen Belkin Art Gallery, University of British Columbia, Vancouver

Museum of Modern Art, New York

National Gallery of Canada, Ottawa

National Media Museum, Bradford, England

Oakville Galleries, Ontario

San Francisco Museum of Modern Art

Vancouver Art Gallery

Victoria and Albert Museum, London

Walker Art Center, Minneapolis

AUTHOR BIOGRAPHIES

GRANT ARNOLD is the Audain Curator of British Columbia Art at the Vancouver Art Gallery. Over the past twenty years he has organized more than thirty exhibitions of historical, modern and contemporary art, including *Mark Lewis: Modern Time; Fred Herzog: Vancouver Photographs; Real Pictures: Photographs from the Collection of Claudia Beck and Andrew Gruft; Rodney Graham: A Little Thought* (with co-curators Jessica Bradley and Cornelia Butler); and *Robert Smithson in Vancouver: A Fragment of a Greater Fragmentation.* He teaches Critical and Curatorial Studies at the University of British Columbia and lives in Vancouver.

MARTIN BARNES is Senior Curator of Photographs at the Victoria and Albert Museum, London, where he has organized exhibitions on historic, modern and contemporary photography, including *Twilight: Photography in the Magic Hour.* Previously, he worked at the Walker Art Gallery, Liverpool. His publications include *Benjamin Brecknell Turner: Rural England through a Victorian Lens* and *Illumine: Photographs by Garry Fabian Miller.*

VINCENT HONORÉ is Artistic Director and Head of the Collection at the David Roberts Art Foundation, London. He previously held curatorial positions at the Palais de Tokyo, Paris, and Tate Modern, London. He has been commissioned as guest curator for a variety of international projects, including *Past Forward* at 176, the Zabludowicz Collection, London, and *From a Distance* at Wallspace Gallery, New York.

EVA RESPINI is Associate Curator of Photography at the Museum of Modern Art, New York. She has organized a number of exhibitions for MoMA, including *Into the Sunset: Photography's Image of the American West, Fashioning Fiction in Photography since 1990* and *New Photography 2007,* which featured the work of Scott McFarland.

SHEP STEINER is an art historian and critic who teaches at the University of Florida. His essays on modern and contemporary art have been published widely in journals and exhibition catalogues. He is co-editor of *Cork Caucus: On Art, Possibility and Democracy.*

Next four pages:
Judges Walk, Looking towards Jack Straw Castle (edition 3/5), 2009

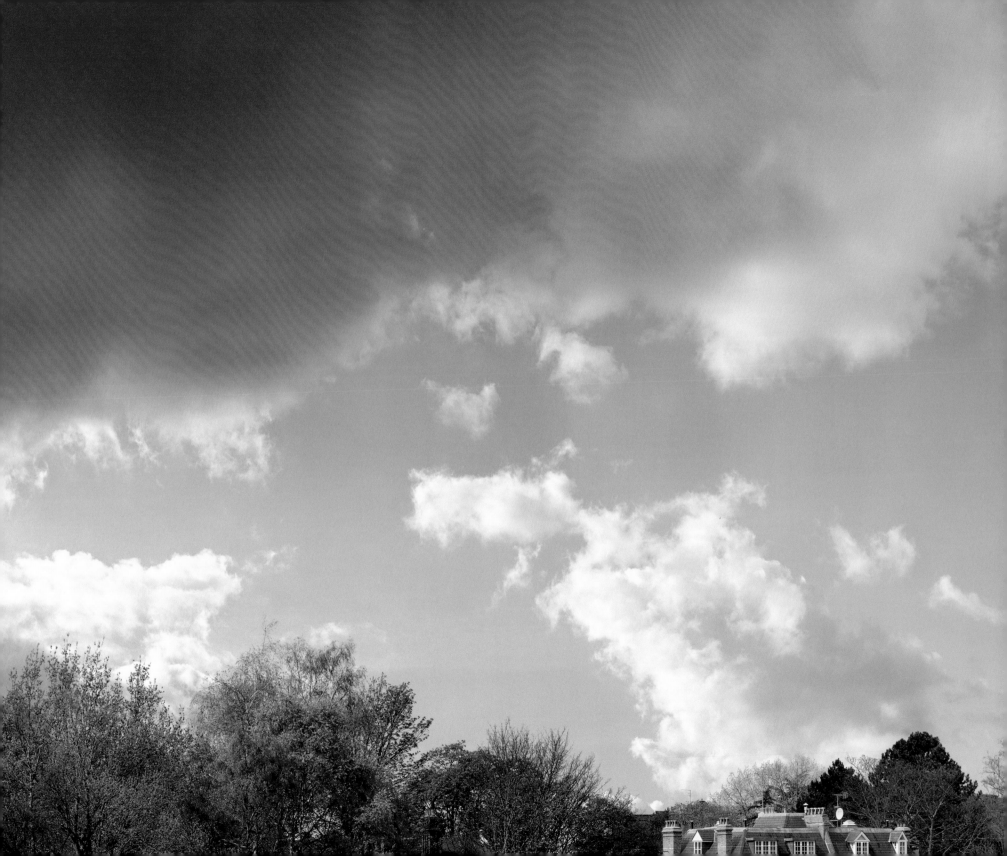

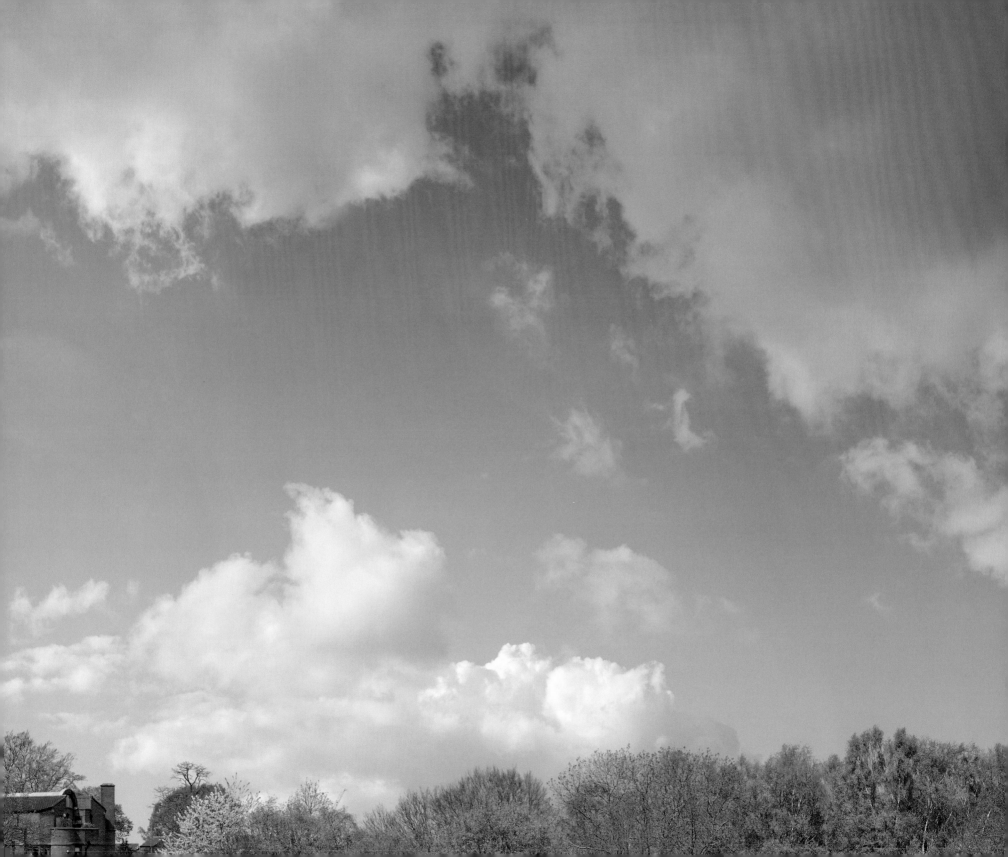

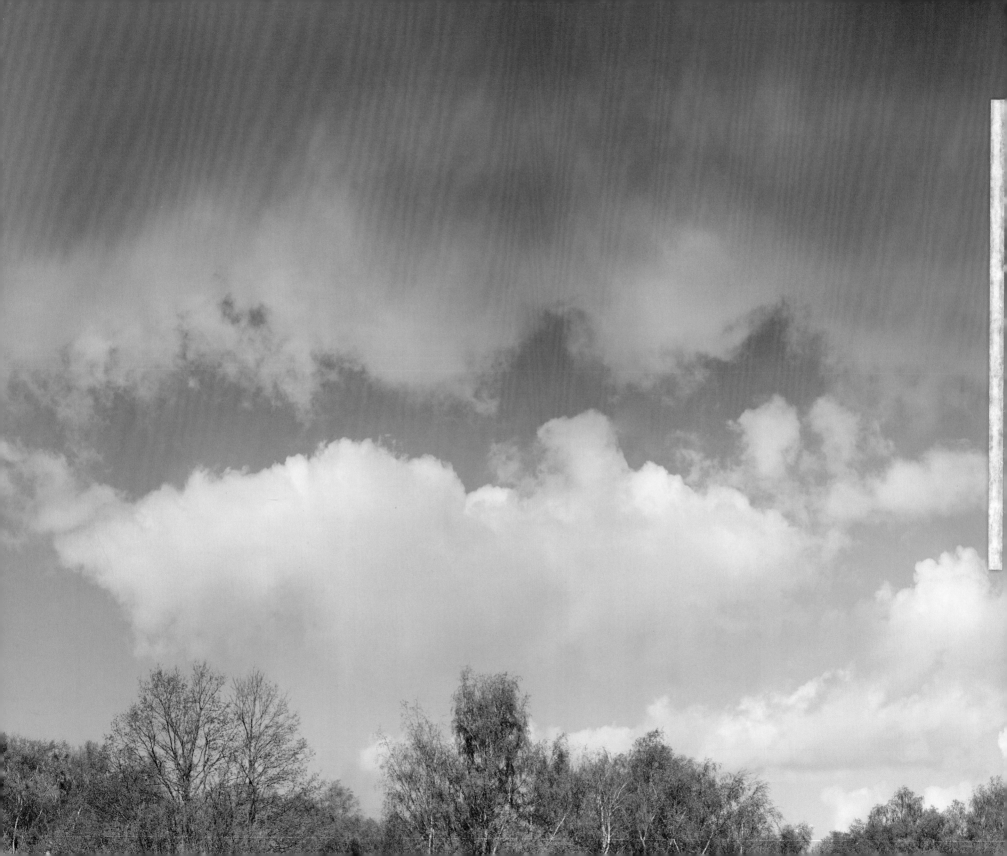

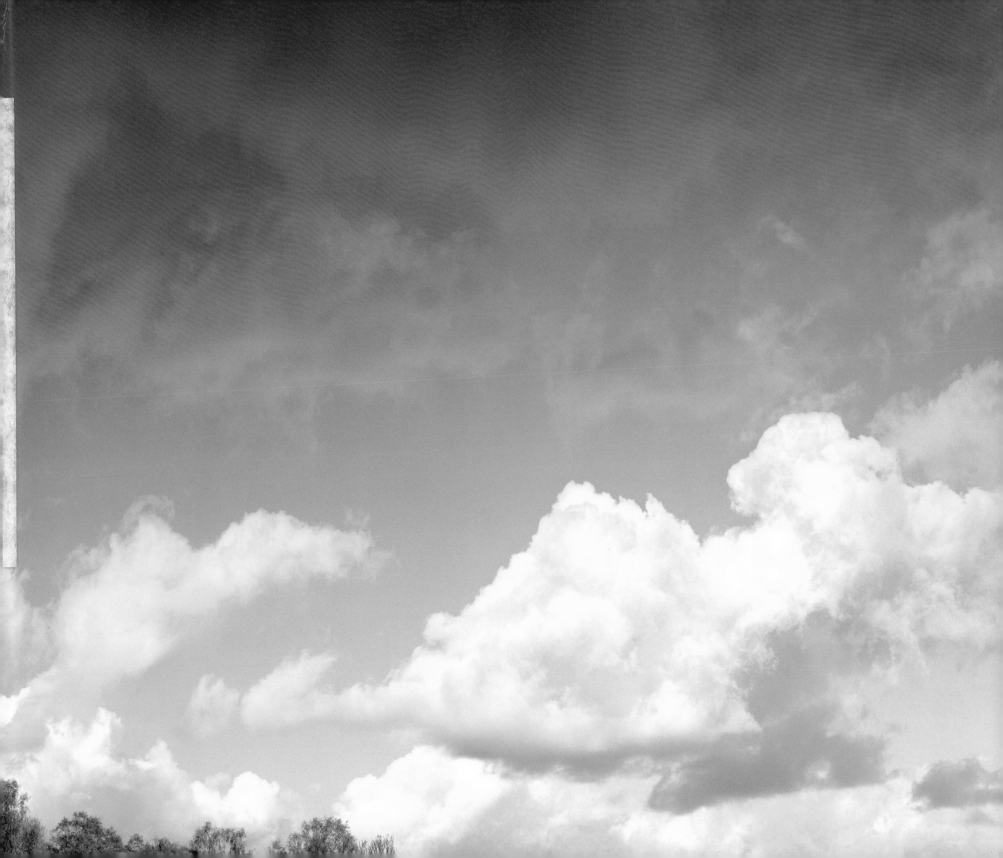

Copyright © 2009 Vancouver Art Gallery
and D&M Publishers Inc.
Photographs © 2009 Scott McFarland
Individual texts © 2009 Grant Arnold, Martin Barnes,
Vincent Honoré, Eva Respini, Shep Steiner

09 10 11 12 13 5 4 3 2 1

Vancouver Art Gallery
750 Hornby Street
Vancouver BC Canada V6Z 2H7
www.vanartgallery.bc.ca

Douglas & McIntyre
An imprint of D&M Publishers Inc.
2323 Quebec Street, Suite 201
Vancouver BC Canada V5T 4S7
www.douglas-mcintyre.com

Library and Archives Canada Cataloguing in Publication
Arnold, Grant. Scott McFarland / Grant Arnold.
Published in conjunction with a solo exhibition of the artist's
work at the Vancouver Art Gallery, Oct. 3, 2009–Jan. 3, 2010.

ISBN 978-1-55365-482-7

1. McFarland, Scott, 1975– —Exhibitions. 2. Photography,
Artistic—Exhibitions. I. McFarland, Scott, 1975– II. Title.
TR647.M315 2009a 779.092 C2009-900945-5

Editing by Grant Arnold and Meg Taylor
Cover and interior design by Studio: Blackwell
Digital image preparation by Ernst Vegt,
Coast Imaging Arts Inc., New Westminster, B.C.
Printed and bound in Canada by Friesens Corporation
Printed on paper that comes from sustainable forests
managed under the Forest Stewardship Council
Distributed in the U.S. by Publishers Group West

The Vancouver Art Gallery is a not-for-profit organization
supported by its members; individual donors; corporate funders;
foundations; the City of Vancouver; the Province of British
Columbia through the B.C. Arts Council and Gaming Revenues;
the Canada Council for the Arts; and the Government of
Canada through the Department of Canadian Heritage.

D&M Publishers Inc. gratefully acknowledges the financial
support of the Canada Council for the Arts, the British
Columbia Arts Council, the Province of British Columbia
through the Book Publishing Tax Credit, and the Government
of Canada through the Book Publishing Industry Development
Program (BPIDP) for our publishing activities.

Front cover: *Sugar Shack, Caledon, Ontario*, 2009
Back cover: *Safelight with Darkroom Chemicals*, 2003–2006

Mixed Sources
Cert no. SW-COC-001271
© 1996 FSC
FSC